POSTCARD HISTORY SERIES

Petoskey

IN VINTAGE POSTCARDS

POSTCARD HISTORY SERIES

Petoskey

IN VINTAGE POSTCARDS

C.S. Wright

ARCADIA

Copyright © 2004 by C.S. Wright.
ISBN 0-07385-3260-6

Published by Arcadia Publishing,
an imprint of Tempus Publishing, Inc.
Charleston SC, Chicago, Portsmouth NH,
San Francisco

Printed in Great Britain.

Library of Congress Catalog Card Number: 2004100695

For all general information contact Arcadia Publishing at:
Telephone 843-853-2070
Fax 843-853-0044
E-Mail sales@arcadiapublishing.com
For customer service and orders:
Toll-Free 1-888-313-2665

Visit us on the internet at http://www.arcadiapublishing.com

CONTENTS

DEDICATION

My parents ensured that my brothers and myself learned to appreciate not only the beauty of the Grand

Traverse region, but also Petoskey, Bay View, and Harbor Springs, as well as the Charlevoix area.

For all of the Sunday drives, family picnics, and days at the beach,

I would like to dedicate this book to Charles S. Wright and Carole M. Wright.

INTRODUCTION

Petoskey, nestled in a cove on the seemingly tranquil shores of Little Traverse Bay, is a town that has uniquely captured and relished its past, cautiously embracing the future. The focus of this book is on Petoskey's early days, as well as its growth and transformation into a year round resort playground. Abundant in natural resources, Petoskey and its neighboring communities, particularly Bay View, Boyne City, Charlevoix, and Harbor Springs, as well as the outlying areas, entice visitors with sweeping vistas and sunsets that are beyond comparison.

In closing, it is my hope that this book will serve to complement other books on the subject. It would be remiss of me not to mention the assistance of Petoskey native Keith Hazelton, as well as Harry Phillips, Matt Abbott, and R.D. Anderson in compiling the materials for this book. Lastly, writing this book would not have been possible, if it were not for the patience and dedication of my wife and children.

One
LAND OF HIAWATHA

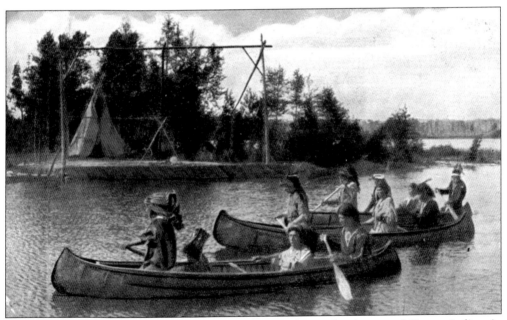

Birch bark canoes skimming across the water, teepees lining the shore, and Ottawa Indians in native attire were not an uncommon sight in the Petoskey area into the early part of the 20th century. In fact, prior to the arrival of European settlers in what is now known as Emmett County, during the 18th century, Native Americans of the Ottawa (or Odawa) tribe inhabited much of the area. The Ottawa, known for harassing the British and French troops stationed at Fort Michilimackinac to the north, were, for the most part, a peaceful group and were recognized as skillful traders. By some accounts, the Ottawa, who lived primarily along the shoreline of Little Traverse Bay, had called this area home since the Paleo-Indian Period, which dates from 10,000 BC until approximately 8,000 BC.

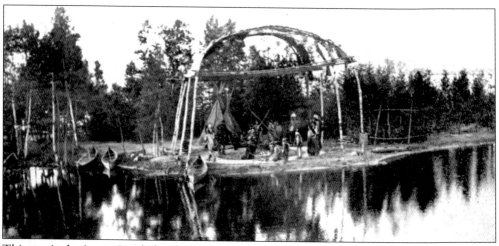

This particular image is titled "The Gambling Scene: Hiawatha Play, Wa-Wa-GA-Mug," and while the exact location is unclear, it does take place near present-day Petoskey. While unlikely to occur these days, there was a time when reenactments of ceremonies, as well as plays, were commonplace among the Ottawa Indians. These events entertained visiting dignitaries and tourists, many of whom had only heard stories about Native Americans and their lifestyle, and served as the first exposure to the Ottawa Indians for many. *The Song of Hiawatha* by Henry Wadsworth Longfellow was, to some extent, inspired as a result of research conducted by Henry Rowe Schoolcraft, Superintendent of Indian Affairs for the State of Michigan. Schoolcraft had researched and written extensively about the Ottawa Indians, as well as the Petoskey area. In his notes about his work on the poem, Wadsworth openly gives credit to Schoolcraft for providing inspiration.

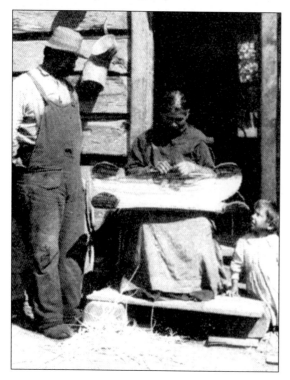

The ancient tradition of building an elm bark canoe is kept alive by a number of Native American tribes, especially the Ottawa Indians. Canoes may be made from any one of a number of different types of bark, and while birch bark is commonly thought of as the primary building material, spruce, pine, elm, or cedar may also be used. The bark is gathered in single sheets, rolled up, and brought home where it is unrolled, flattened out, and secured in place by on a wooden canoe-shaped frame so that shaping can begin. The hull of the canoe, made up of gunwales, ribs, and a stem piece, are steamed and/or soaked, bent into shape, and put out to dry. The hull of the canoe is shaped by the ribs, which not only hold the inner lining in place, but also give it a great deal of strength. After the canoe is caulked with gum and pitch, it is then watertight and seaworthy.

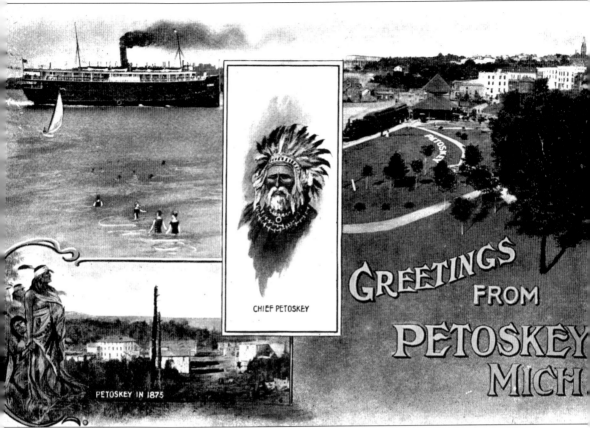

CHIEF PETOSKEY

PETOSKEY IN 1875

GREETINGS FROM PETOSKEY MICH.

The virtues of a growing young town—one that is accessible by steamer and rail, has a growing manufacturing base, and a pleasing landscape—are all integral to this greeting, yet it is the image of Chief Pet-O-Sega, or Petoskey, which serves as the centerpiece for this particular postcard. Chief Petoskey, the son of a Frenchman who married an Ottawa princess and went on to become a tribal chief, actually owned much of the land on which the town of Petoskey now stands. The chief, whose name fittingly translates to "rays of the rising sun," was not only a successful fur trader and merchant, but also served as an ambassador for his people. Originally known as Bear River, the town was renamed Petoskey in honor of the chief in 1873.

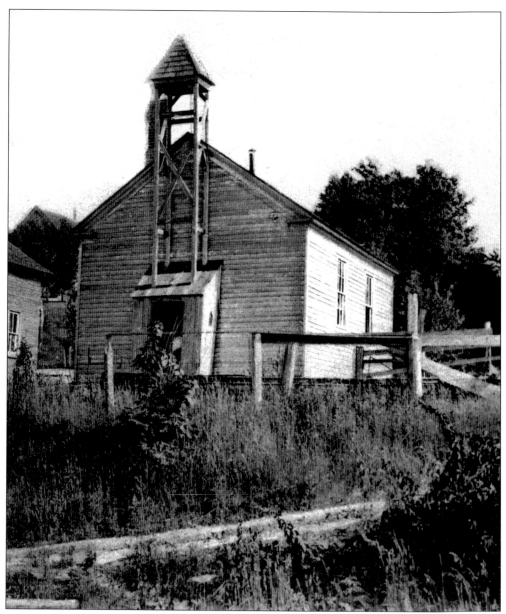

Commonly referred to as the Old Indian Mission, the St. Francis Solanus Mission, built in 1859, is the oldest standing building in Petoskey. Jeanne Baptiste Trotochaud built the mission, located on West Lake Street, on land that he donated to the church. The dedication ceremony took place on July 23, 1860, with Bishop Frederic Baraga officiating. The small church, which has been restored twice over the years, served as a gathering place not only for services, but also social events. Much to the surprise of visitors, a passage of the sermon would be given in English and then it would be repeated by one of Chief Petoskey's sons in the Ottawa language. In fact, according to R.H. Little, the congregations enjoyed hearing the Indians sing hymnals in their native tongue.

At 108 years of age, an elderly gentleman by the name of "Smoke Shakenavoy," a member of the Ottawa tribe, sits on the stoop of his home just outside of Petoskey. Sights such as this one were commonplace in the early part of the 20th century and, while a significant portion of the population was previously comprised of Native Americans, this is no longer the case. Despite the fact that slightly over 100 years ago, the Ottawa made up the majority of the population in and around Petoskey, recent census figures suggest that they now comprise only 3.11 percent of the population.

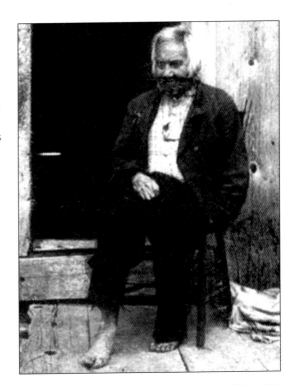

The Crooked River is one of several waterways that comprise the Inland Route, along with Crooked Lake, Burt Lake, Indian River, Mullet Lake, and the Cheboygan River. For centuries, this inland chain of waterways, which at one time included Round Lake and Iduna Creek, provided safe passage for both Native Americans and early European settlers. The inland waters were less dangerous than those of Lake Michigan, allowing for a much safer journey. Several portage points existed on the Inland Route, the primary one from Lake Michigan was located near Menonaqua, between Kegomic and the southern border of what is now the Petoskey State Park, as well as at varying sites along Iduna Creek. By 1874, mail was being transported on the Inland Route and, in 1880, with the growth of the logging industry and the surge in tourism, steamers were making daily runs from Petoskey and Bay View to Conway, Oden, Ponshewaing, and Alanson.

Aptly named, Lakeshore Drive in Petoskey follows the contour of Lake Michigan. A drive along this little stretch of U.S. 131 takes sightseers past a number of the parks and beaches for which Petoskey is so well known. For the most part, the beaches of Little Traverse Bay remain untouched with stately birches and pines rising up out of the bluffs leading to the beach where they line the shores of Lake Michigan. Residents and tourists alike flock to the shoreline during the summer months to cool off in the waters of Lake Michigan and perhaps search for Petoskey stones. A stroll down the beach leads past the Historic Gaslight District, all the way to Bay View, and further to the north, Harbor Springs.

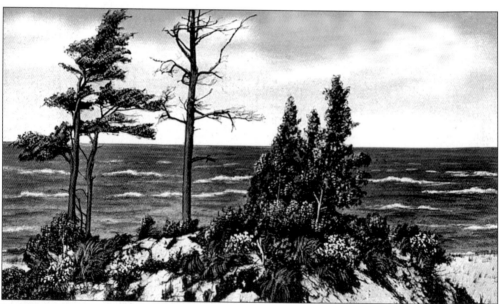

Northern Michigan is known for its long stretches of sandy beaches, lining the shores of Lake Michigan. Petoskey and the entire Little Traverse Bay area are no exception to the rule. Here, waves crash onto the beach, changing the landscape from one day to the next. From down around Glen Arbor and Empire, with the Sleeping Bear Dunes National Lakeshore, to the most northern points of Leelanau County, following the contour of Grand Traverse Bay and along the entire shoreline to the glimmering waters of Little Traverse Bay, the waters of Lake Michigan and her beaches are truly a sight to behold. These waters are the only place in the world that Petoskey stones are found. The Petoskey stone, so named after Chief Pet-O-Sega, is a stone with hexagonally shaped fossilized coral embedded within it. It is also the state stone of Michigan.

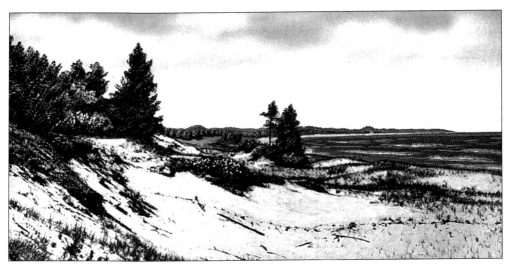

Menonaqua Beach is located just to the north of Bay View, midway between Petoskey and Harbor Springs. A view from Menonaqua, with the shoreline of Petoskey to the south and Harbor Springs to the north, is nothing short of awe-inspiring. Here, during the summer months on Little Traverse Bay, sailboats and yachts dance on the waves, yet it is not difficult to envision the days not so long ago when these waters were home to freighters hauling lumber and limestone, as well as steamers ferrying passengers from such far away destinations as Chicago, Cleveland, Detroit, and Milwaukee. Today, residents and tourists flock to Menonaqua Beach during the summer months to picnic, swim, build sandcastles, fly kites, or simply to feel the sand between their toes, catch the warm breeze as it comes off of Little Traverse Bay, and enjoy the view.

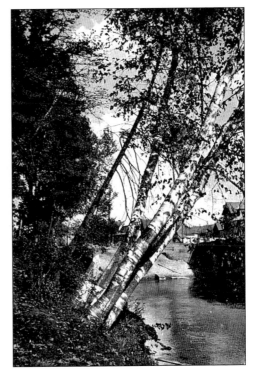

Leaning out over the banks of the Bear River, these birch trees all but obscure the gristmills, lumber mills, and tanneries that were so crucial to Petoskey's early economic development. Snaking its way from down near Walloon Lake in Charlevoix County all the way north to Petoskey, where it empties out into Lake Michigan, the Bear River was the lifeblood of this community in its early days, and remains so to a great extent. On any given day, there are fishermen lining the banks of the Bear River, as well as dropping their lines in from the Lake Street Bridge. The river's mouth, which has been redesigned a number of times over the years, now features a parking lot, restrooms, and a 350-foot boat docking pier. There are still a number of birch trees, as well as a barrier-free walkway, leading from the mouth of the river up to the Lake Street Bridge.

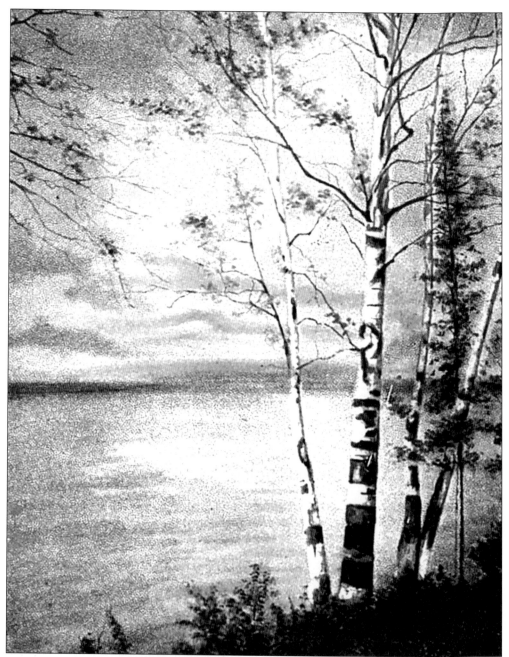

Sunsets on Little Traverse Bay are nothing short of spectacular. Much of this little corner of northwestern Michigan remains untouched by human hands, although pristine views such as this may be fleeting considering the recent surge in construction; yet they are an integral part of daily life in Petoskey and the surrounding area. The light shimmers and dances across the glass-like waters, defying description, like most of nature's wonders, and every Petoskey resident knows that the only way to truly appreciate it is to live and breathe it. In Petoskey, as with most of northern Michigan, very few aspects of life are certain, yet each day that the sun shines, residents and tourists alike can look forward to another glorious sunset on Little Traverse Bay.

Two
AN EARLY SETTLEMENT

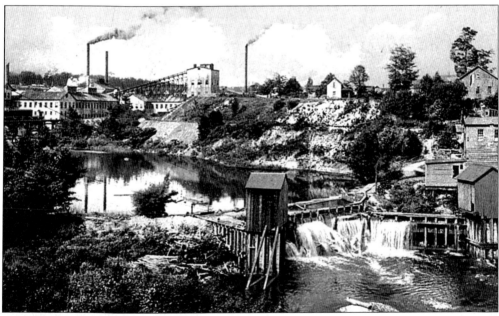

Back in the days when Petoskey was known as Bear River, and for a short time, Porter's Village, through the time the town was officially granted a charter in 1879, it was one of the centers of industry in northern Michigan. The Bear River, which flows through town, and Petoskey's location on Little Traverse Bay were instrumental in its early development. It was here, on the banks of the Bear River, that tanneries, sawmills, and quarries flourished from the 1870s until the early 1900s. The Chicago & Indiana Railroad made its first stop in Petoskey on November 25, 1874, and along with the steamers and freighters of the Great Lakes, this enabled the transportation of both cargo and passengers. While a number of hearty individuals spent summers vacationing in Petoskey during its formative years, the lumber industry was the economic mainstay of the area. In fact, lumber from Petoskey and all of northern Michigan was instrumental in rebuilding Chicago following the Great Fire.

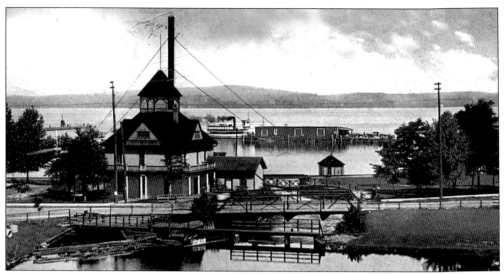

The Bear River meanders through town, the waters from its mouth flowing into Little Traverse Bay. Today, at the site of the old power plant, fishermen dot the banks of the river during the summer months. In the distance, on the opposing shoreline, are Harbor Springs, Harbor Point, and Wequetonsing. It was not all that long ago that here, at the mouth of the river, there were logjams and lumberjacks working feverishly to free them up, and the bay bustled with the activity of one of northern Michigan's busiest shipping ports. While freighters and steamers no longer dock at Petoskey, and logjams, as well as lumberjacks, are merely distant memories, the Bear River still flows ever so slowly into Little Traverse Bay, and during the summer, sails billow on the horizon between Petoskey and Harbor Springs.

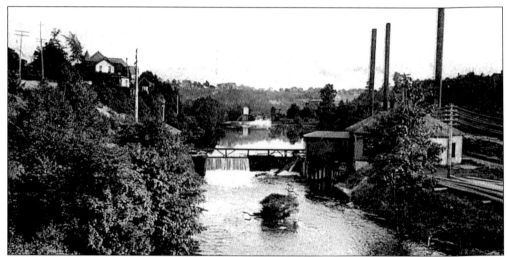

Looking far different in 1906 than it does today, a view up the Bear River shows a rather rural scene, one that is experiencing a degree of economic growth. Smokestacks loom in the background, a reminder that Petoskey was once a manufacturing town, and while the sawmills and tanneries no longer exist, they have forever changed the landscape of this small town. Local residents still work diligently in an attempt to reclaim the natural beauty of the Bear River, a waterway that was once severely damaged by the same people who were so instrumental to Petoskey's growth.

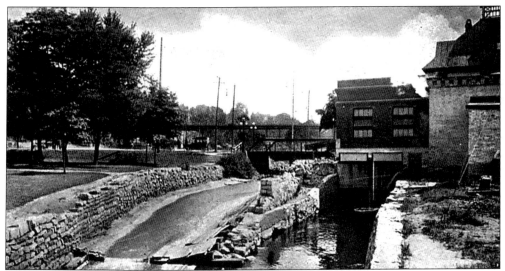

Many other communities in northern Michigan were struggling with how to supply electrical power, as well as a fresh water supply to both businesses and residents, although for Petoskey this was not a problem. For several decades following the turn of the century, a single water source, the Bear River, served as the town's primary power source. Not only did the river have a current sufficient to meet the town's needs, it was also readily accessible, as demonstrated by the numerous mills and tanneries that lined its banks a bit further upstream. While the town still operates its own waterworks, the growing population necessitated securing its electricity from other sources.

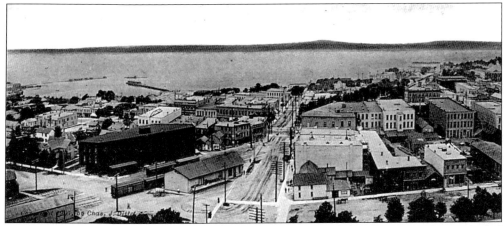

A view of Petoskey across Little Traverse Bay from atop the spire of the St. Francis Cathedral captures, to some extent, the tremendous economic transformation and growth that took place in the early part of the twentieth century. Despite the prevalence of the logging industry, many of the more modern buildings in Petoskey were made of brick. This was the result of a rash of fires that swept the downtown area, as happened in a number of logging towns. Petoskey residents, as well as their guests, are proud of the fact that little has changed in this sleepy community, other than for the usual road and technological improvements, a new facade on a storefront every now and then, and the annual beautification of city parks. Uniquely personalized downtown areas with a relaxing feel, quaint historic buildings, and the renowned Gaslight District are just a few things that make Petoskey a special place to visit.

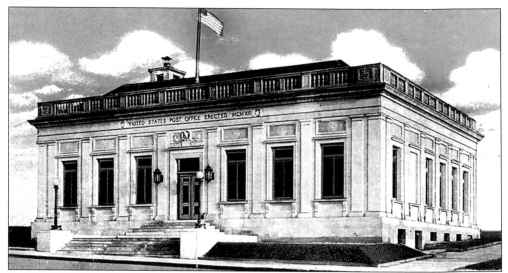

It wasn't until 1913 that Petoskey's population warranted the construction of its own post office, pictured above, although mail service in the area began more than 50 years earlier. On December 2, 1857, when the town was still known as Porter's Village, the Reverend Andrew Porter began serving as the area's first postmaster. While mail service was slow and at times unreliable, this soon changed with the arrival of the railroad. In 1873, the same year that the Grand Rapids & Indiana Railroad started making regular stops in the area, the postal address was changed from Porter's Village to Petoskey and Dr. William Little was appointed the first official postmaster. Mail service, via the railroad and steamers, was more reliable during the summer months than in the winter.

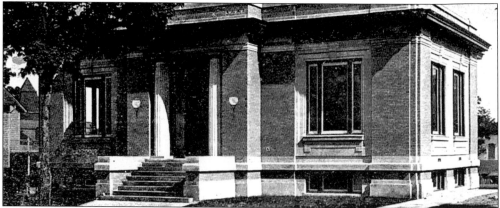

Originally established in 1905, the Petoskey Public Library was completed in 1908. Construction of the library, which serves all of the residents of Emmett County, was made possible by a grant from the Carnegie Foundation. While the original library, located at the end of Waukazoo Avenue, on Mitchell Street, has served its purpose, the recent surge in population has made it necessary to build a larger, more functional library. In August of 2000, the residents of Petoskey approved a millage for a new library, and in July of 2003, a groundbreaking ceremony took place at the site of the former Bell Building, located across the street from the Carnegie Library. Renovations to the former Bell Building, which will house the new library, should be complete by the summer of 2004. In the future, the Carnegie Library will be used for special events.

Lockwood Hospital, now a part of Northern Michigan Hospital, was one of Petoskey's first hospitals. The hospital, initially established in 1902, boasted ten private rooms, three wards of three beds each, and an operating room. Over the years, the hospital grew, adding a nursery, x-ray equipment, and as time went on, surgical and obstetrical rooms. In 1909, seven years after Lockwood Hospital was built, Drs. John and George Reycroft filed articles of incorporation for the creation of what was to become Petoskey Hospital. These two hospitals, along with several lesser-known facilities, eventually became what is now known as Northern Michigan Hospital. Today, Northern Michigan Hospital is a 243-bed health care facility, providing services to residents of over 24 counties in northern Michigan.

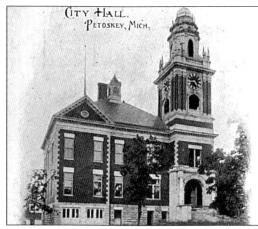

CITY HALL,
PETOSKEY, MICH,

Petoskey, Mich.

🌸🌸🌸

The jingling of this little bell
Is jingling to you that I'm well
And jingling more than I can tell
Of the jingling time I'm having
---so all's well.

Whimsical and upbeat, this message refers to the jingling of a bell, the one that adorned Petoskey City Hall from 1902 until it was razed in 1966. The construction of the city hall, or old courthouse as some residents know it, was instrumental to moving the county seat from Harbor Springs to Petoskey. In October of 1901, the Emmett County Board of Supervisors agreed to place the question of moving the county seat on the ballot, and in April of 1902, a two-thirds majority passed the proposal. A familiar sight and sound to the people of Petoskey, the clock and its bell were a gift from Mrs. W.L. Curtis in 1902. In need of more modern facilities, the brick and sandstone building was torn down in 1966. While the old clock was removed prior to the razing, its hourly chimes have yet to ring again in Petoskey.

GR&I Park, named for the Grand Rapids & Indiana Railroad, is situated near the site of the old railroad depot in downtown Petoskey. In the late 19th century and into the early 20th century, it was commonplace for railroad companies to build a park near the depot, and then passengers would be more likely to gain a positive perspective of the town as they exited the train. Parks such as the GR&I gave passengers a place to rest and freshen up while waiting for a carriage or dummy train, which would take them on a short journey to places such as Bay View and Harbor Springs. This particular park is also of historical significance in another sense. During the summer of 1925, a young writer by the name of Ernest Hemingway roomed at a boarding house on Howard Street in downtown Petoskey while working on *Torrents of the Spring*. In this book, he makes reference to the birch trees in the park near the railroad depot.

A long, winding path lined with beeches, maples, and oaks leads into the country setting known as City Park. Much of the early settlement in and around Petoskey took place on the water's edge; the dense forests further inland were, for the most part, untouched. While little development took place in these areas during Petoskey's formative years, there were a few areas such as City Park where residents could enjoy peace and solitude away from the growing city.

City Park was unique not only because it was a wilderness area on the far eastern reaches of Petoskey, but also because it boasted an inland lake. Swan Lake, pictured here in the background, was actually home to a number of different types of birds, most notably swans. While wilderness areas are still a major attraction in the Petoskey area, they were somewhat more dangerous around the turn of the century. It seems as though the bears were not pleased with the fact that people were encroaching upon their territory, and as a result, there were a number of attacks over the years.

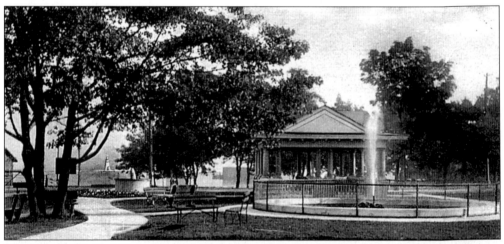

Mineral Springs Park, located on the Bear River, is an example of one of the many reasons people flocked to the Petoskey area in its early years. The mineral springs found in Petoskey, Bay View, and Harbor Springs not only enticed visitors to come to the area, but also served as one of the foundations of the local economy. At one time, local hotels touted the health benefits of the mineral springs. While the focus was, for the most part, on tourism, many residents would take jugs down to the park and fill them with water from the spring. While the attraction to the springs has waned over the years, their very existence played an important part in the development of the area. Today, Mineral Springs Park tends to be more popular with children, passersby, and the fishermen that dot the banks of the Bear River than with those in search of a miracle cure for ailments.

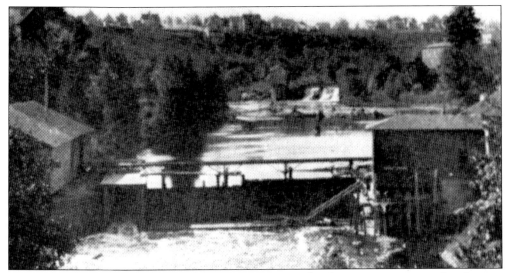

Bear River, once the lifeblood of Petoskey's booming lumber economy, meanders its way through the southern portion of town and empties into Little Traverse Bay. In the spring, anglers line the banks of the Bear River in hopes of landing a brown trout, steelhead, or whitefish. From Labor Day until mid-October the focus is on catching one of the many Chinook salmon that make their way up the river each fall. The Department of Natural Resources releases approximately 9,000 steelhead trout and 8,000 brown trout into Bear River each year, and while fishing is popular, it is by no means the only pastime. There are also a number of bike and walking paths, as well as several parks, along the banks of the Bear River, from Mitchell Street down to the Bear River Pier on Little Traverse Bay.

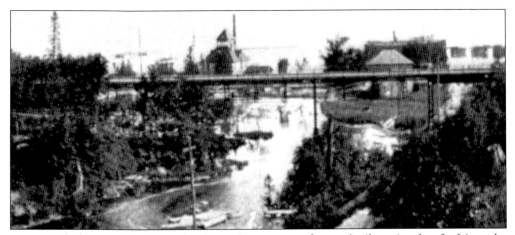

Bear Creek, located to the South of Petoskey, is one of several tributaries that feed into the Bear River. In fact, Bear Creek starts in Charlevoix County near the southern end of Walloon Lake. This creek was once an integral part of Petoskey's economy. As lumber companies began looking further inland for timber, they focused on stands of trees located near waterways. Bear Creek, with its waters flowing into the Bear River, was a natural choice. Towards the end of the 19th century, with the lumber industry beginning to wane and tourism becoming vital to the economy, inland steamships started ferrying passengers on Bear Creek. Today, the loggers and steamships are merely memories, yet Bear Creek remains a favorite among the fishermen who frequent its banks.

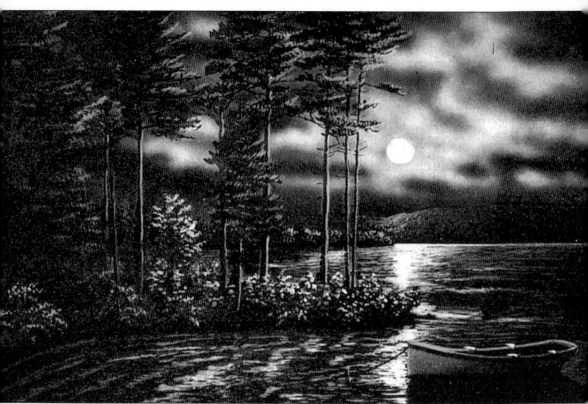

Few sights are as memorable as this one, and for some, a vision such as this can leave an impression that will last a lifetime. Gazing out over the moonlit waters, one can almost hear the chirp of crickets and the water gently lapping up on the beach. All the while, a lone skiff rocks to and fro under the full moon, possibly awaiting the arrival of an early morning angler. Often taken for granted by those fortunate enough to live in northern Michigan, such sites are not all that unusual in the Petoskey area. In fact, the natural surroundings are one of the primary reasons that Petoskey lures so many visitors each year.

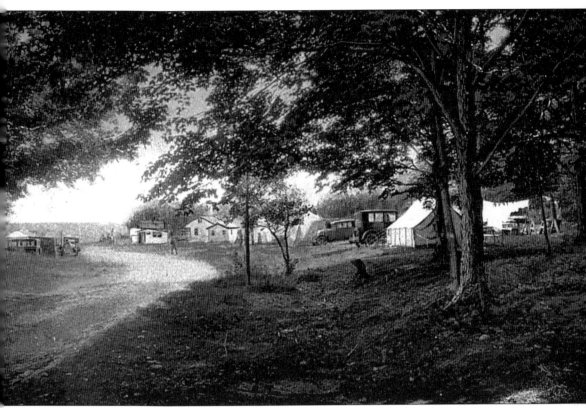

Magnus Park, located on Little Traverse Bay to the north of Bayfront Park and Bear River Park, is a perfect place to while away the day on the shores of Lake Michigan. The park, complete with 63 modern campsites and a playground, is on East Lake Street in Petoskey. Whether in search of Petoskey stones, an awe-inspiring sunset, or merely a fun day at the park, this is one of the premier spots in Petoskey. It is difficult to believe that Magnus Park, once one of the hubs of shipping activity in the area, is actually in the city. Its pristine beach littered with skipping stones and driftwood, the waves of Little Traverse Bay gently lapping up onto the shore, it is no wonder that its popularity only grows with each passing season.

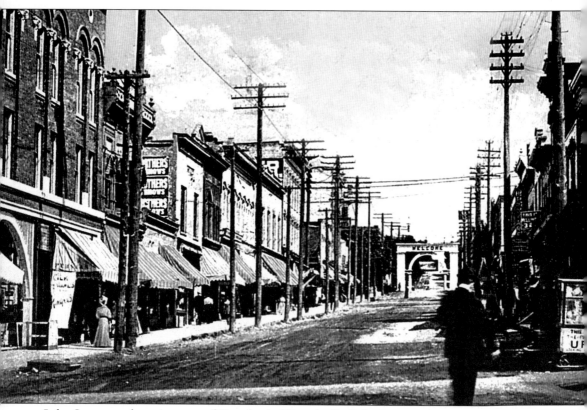

Lake Street, at the very core of Petoskey's Historic Gaslight District, has been home to a number of primarily independent shops since the 1890s. In earlier days, the shops on Lake Street catered almost exclusively to an affluent clientele, although today it is possible to find something for almost anyone. Quaint and untouched by modern standards, the shops on Lake Street have managed to retain much of their past. While it is highly unlikely that the street would be as unpopulated as it appears here, it remains one of Petoskey's true gems. Lake Street extends from Kalamazoo Avenue through downtown, across the Bear River and along the shores of Little Traverse Bay, finally reaching its most eastern point at Magnus Park.

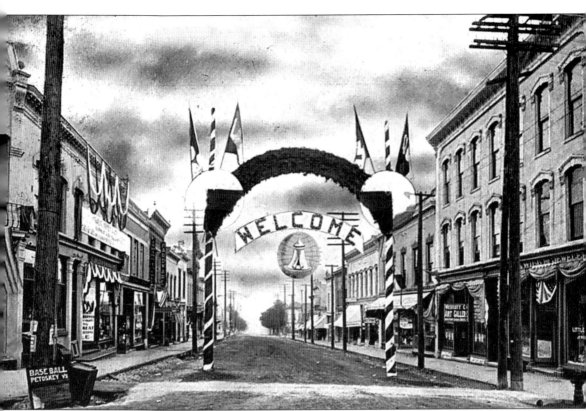

Since its earliest days, Petoskey has been known for its hospitality, and if there was any doubt, residents erected this welcome sign on East Lake Street. Lake Street, along with the rest of the Historic Gaslight District, was listed on the National Register of Historic Places in 1986. This area, also known as the "Midway," is at the center of Petoskey's business district. Roughly bordered by Division, Michigan, Petoskey, and Rose streets, the Gaslight District is so named for the gas lamps that still line the streets. The facades of these buildings remain unchanged; some of the streets are still lined with brick and the town's residents are as hospitable as their forefathers were in the 1890s.

It was not unusual for parks such as GR&I Park to be outfitted not only with restrooms, but also with small cottages or gazebos. While these were, at the very most, day cottages and considered to be rustic, they did provide some protection from the elements. For many people moving to the area and others merely vacationing, the birch trees and vine-covered cottages of GR&I Park would be their first glimpse of the Petoskey area. Luckily, the town fathers had the foresight to plan such parks, given the fact that local industry raised so much dust. Petoskey is a far different place today than it was 100 years ago, and it is safe to say that both the residents and the tourists like it that way.

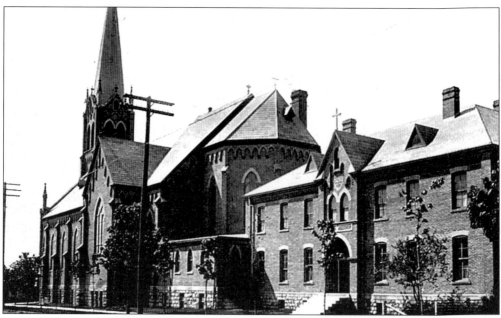

By 1879, the number of Catholic families living in the Petoskey area had grown to the extent that a larger church was needed. As a result, a new church and school, St. Francis Xavier, was built on the corner of State and Howard Street. Once again in 1881, the parish had outgrown its new home and was replaced by a newer, more spacious building. Yet, the parish continued to grow, and in a few short years, it was time to consider rebuilding once again. In 1898, the Building Fund Association was created in order to plan for the future of the church, and in 1902, those plans were put into action. The Neo-Gothic structure was moved to its new home on the corner of Michigan and Howard Street in September of 1902.

The First United Methodist Church of Petoskey, now known as the Petoskey United Methodist Church, was established in October of 1873 when the Reverend George L. Cole held services at the home of Louis Petoskey. A short time later, the size of the congregation had grown to the point where services were held in the dining hall of the now-defunct Rose Hotel. In 1875, a small schoolhouse was built in order to accommodate the congregation, and plans were set in motion to erect a church. The church itself was completed in the fall of 1890, although the Mitchell Street parsonage was not purchased until 1895. Still growing, and in need of more room, the First United Methodist Church held its last service in downtown Petoskey on November 9, 1981. The congregation, which has been renamed the Petoskey United Methodist Church, is now located in Bear Creek Township.

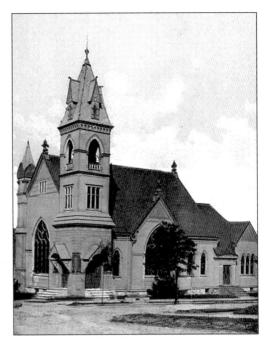

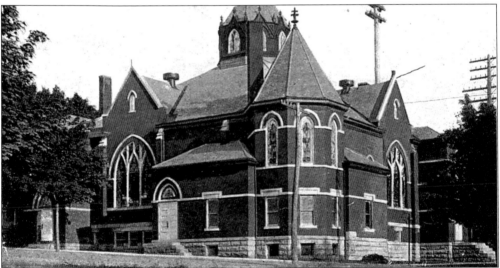

In 1885, the Baptist congregation in Petoskey started meeting and holding services in a building adjacent to the current church, although due to the growth in membership and the charity of one man, within 25 years a new facility was built. Located on the corner of Michigan Street and Waukazoo Avenue in downtown Petoskey, building the new church was made possible by the charitable donation of a steamship magnate wishing to memorialize his mother, who had attended church services in Petoskey during the summer months. Parr Memorial Baptist Church, an imposing brick structure, was finally completed in 1910. Since its inception, the Parr Memorial Baptist Church has been active not only in the local community, but various members of the congregation have ministered throughout the United States and in a number of foreign countries. The building where the congregation originally held its services is now home to the local synagogue, Temple B'Nai Israel.

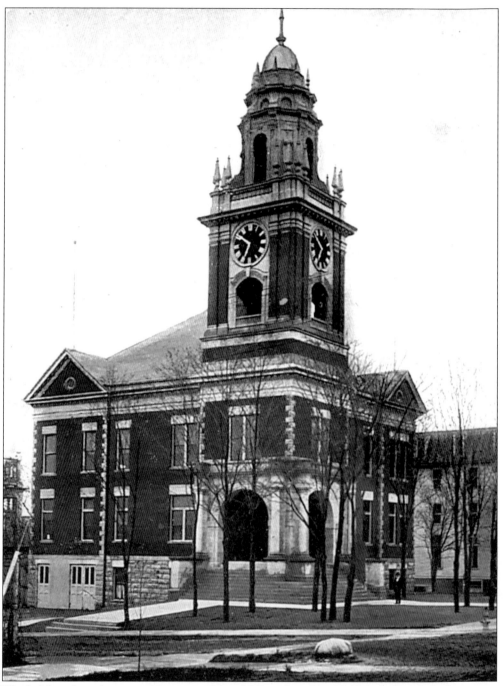

The brick and sandstone architecture of the old Petoskey City Hall, its bell and clock tower a familiar sight to residents and tourists alike, is now nothing more than a distant memory. The building, which stood on the same corner for over 64 years, was razed in 1966 to make way for newer, more spacious surroundings. Historically significant in that its construction played a vital role in moving the county seat to Petoskey, it also served as an example of early 20th century institutional architecture.

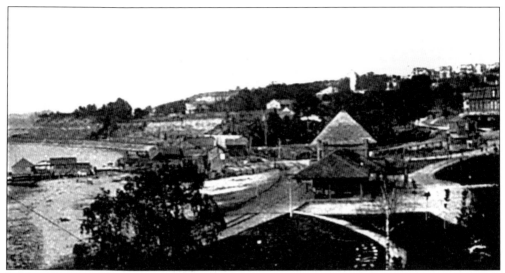

Looking south of the Chicago & West Michigan Railroad Depot, Bear River, and the Gaslight Historical District, it is possible to envision what Petoskey must have looked like at the turn of the century. To the north lay Bay View and Harbor Springs, now primarily known as summer resorts for affluent vacationers. Yet, it was not all that long ago that people flocked to Bay View for its educational and religious camps. By the same token, Harbor Springs was as well-known as Petoskey for its hotels and mineral springs. To this day, Bay View, Harbor Springs, and Petoskey all remain popular vacation destinations.

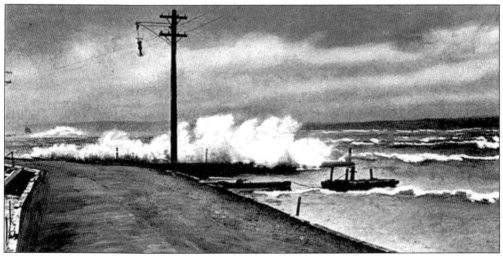

For the most part, Little Traverse Bay, an inlet of Lake Michigan, is serene and beautiful—although every once in a while, a storm such as the one pictured here comes in off of the lake. Storms on Lake Michigan, whether merely squalls or part of larger storm systems, are beautiful to watch, but can also be quite dangerous. While there are some people who believe that Little Traverse Bay offers somewhat of a safe haven, they are sadly mistaken. Granted, there is nothing quite like watching whitecaps as they roll up onto the break wall, yet day sailors and old salts alike will be the first to admonish novices intent on challenging the forces of nature. In fact, storms such as this one, while exhilarating to watch from the beach, are most probably best viewed from the safety and comfort of a residence.

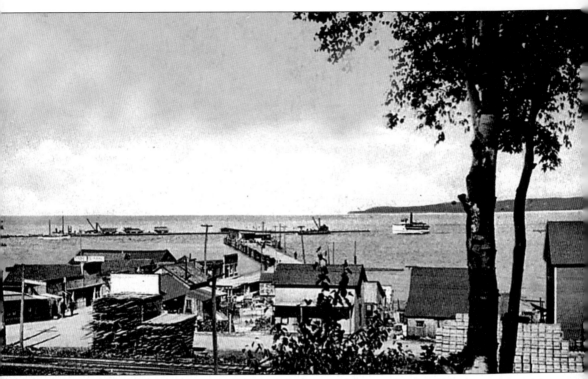

Petoskey's harbor has remained a hub of activity through the decades. The traffic caused by freighters and steamships, which were so crucial to the area's early development, began to fall off once the first railroad tracks were laid. The demise of the lumber industry, along with the completion of county, state, and interstate highways, forever changed the complexion of Petoskey's waterfront. Bayfront Park lies just to the north of the breakwater now, as does the old Chicago & West Michigan Railroad Depot. On summer days, recreational boats of virtually every type and size grace the waters of Little Traverse Bay.

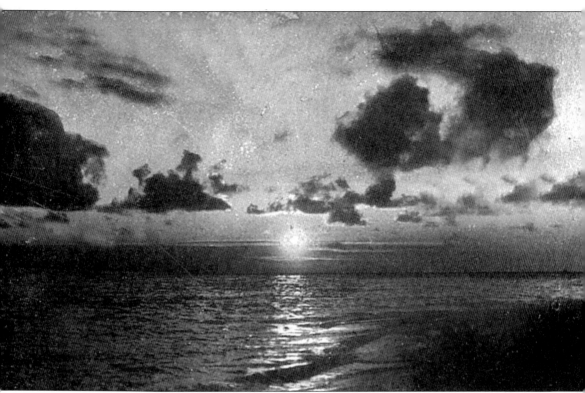

A burned orange sun shines its last glimmering light across Lake Michigan and the waters of Little Traverse Bay before it sinks slowly into the horizon. Spectacles such as this one are common sights for those who frequent not just the beaches at Petoskey, Bay View, and Harbor Springs, but the entire Gold Coast of Lake Michigan. It is obvious, even to the casual observer, that sunsets have a great deal in common with snowflakes; that is, no two are exactly the same. Residents and visitors alike relish these last rays of light, this unique combination of colors and hues, as they shimmer and dance across the water never to be seen in concert together again.

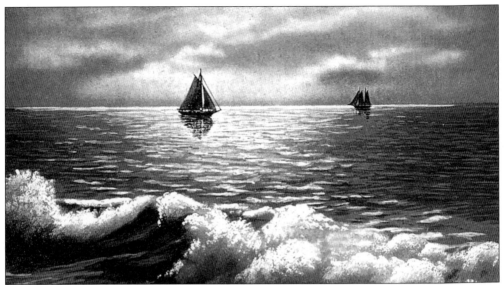

These schooners, one sporting two masts and the other sporting three, appear to be making their way across Little Traverse Bay, most probably in search of safe harbor prior to sunset. Sailing on Little Traverse Bay is an experience that, if given the opportunity, should never be passed up. Once out on the lake, it is easy to imagine the multitude of reasons that both the Native Americans and early pioneers took refuge and built settlements on this narrow strip of land, this fishhook-shaped inlet. From as little as one hundred yards out on Little Traverse Bay, it is possible to see most of Petoskey, Bay View, and Harbor Springs.

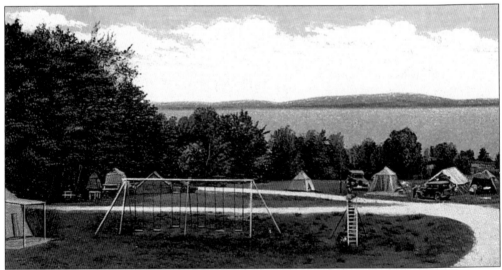

Magnus Park, located on West Lake Street, is just south of the Bear River. At first glance, Magnus Park seems like any other park, yet the fact that it includes over 1,000 feet of Little Traverse Bay shoreline, a bathing beach, 72 modern campsites, picnic facilities, a play area, and bike paths make it a very unique place, especially since it is only a short walk from downtown Petoskey. The overlook at Magnus Park, known for its breathtaking views of Little Traverse Bay, is called "Wayside Park." To the north of Magnus Park is Bear River Park, a veritable fisherman's paradise, and even further still is Bayfront Park.

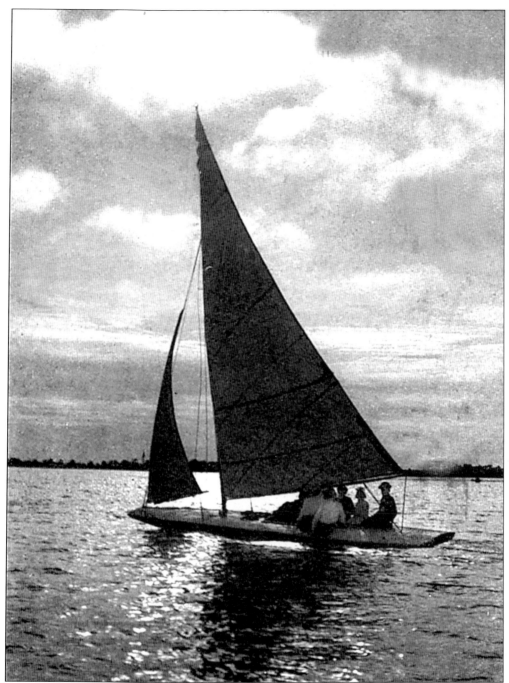

Sailing under the moonlight on Lake Michigan, whether it is on Grand Traverse Bay or Little Traverse Bay, is one of the most breathtaking and romantic pastimes. One can see the reflection of the moon's light in the bluish-gray waters of the lake, the sails billowing ever so slightly in a gentle breeze, and the lights of the towns illuminating the shoreline that seems ever so distant. It is moments like these, calming and relaxing, that help to perpetuate a serenity and peace of mind found in few places outside of northern Michigan.

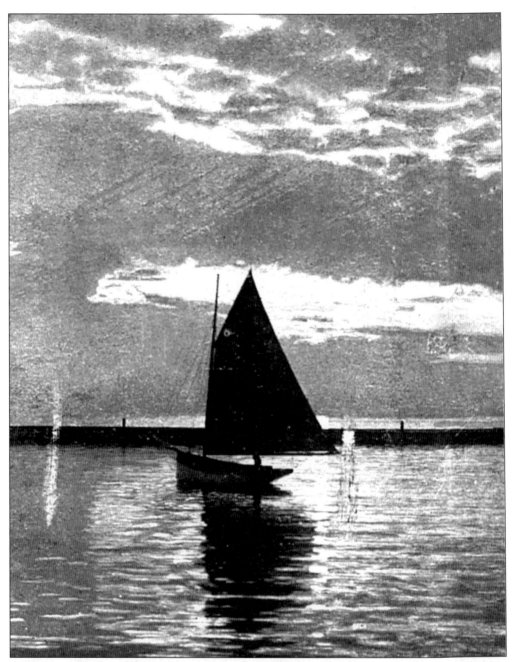

There are few experiences that can compare with a Petoskey sunset. Whether onshore watching the boats as they sail into harbor for the night, or better yet, serving as one of the crewmembers on any one of a number of watercraft, it will undoubtedly be a memorable occasion. The waters of Little Traverse Bay are, as most of the ports on Lake Michigan tend to be, full of billowing sails from sunrise until sunset during the summer months. As the setting sun seemingly dips into Little Traverse Bay, the colors in the evening sky appear to shimmer across the water. The popularity of the Petoskey area has been on the increase for over 100 years. To understand the reason, all it takes is seeing a sunset.

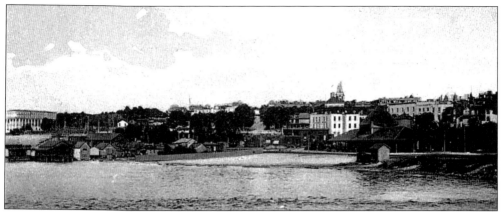

A pleasant summer day, adrift on the waters of Little Traverse Bay, affords boaters and fishermen alike a spectacular view of downtown Petoskey. From here, it is possible to view Bay Street, the docks, Bear River, and much of the Historic Gaslight District. While the natural landscape has changed a great deal in recent years, particularly with the construction of Bay Harbor to the south of town, Petoskey itself remains a sleepy village. To the north lay Bay View, Harbor Springs, and Harbor Point. To a great extent, the architecture, character, and beauty of this entire area have become an integral part of northern Michigan's heritage.

While these folks appear to be somewhat better off than most of the early settlers, there may very well have been a day when their fellow settlers referred to them as "mossbacks." When the federal government first started selling land grants in northern Michigan, the offer of 160 acres was initially made to Civil War veterans. At the time, there were few jobs and little money to be made in the Petoskey area. The farms did not yield what the homesteaders had anticipated, and in an effort to make ends meet, they made clothing out of old burlap bags. As a result, residents began referring to them as "mossbacks."

It was not uncommon in the early part of the 20th century for couples to have large families, especially those who lived in rural areas or on farms. By modern standards, a family of six children seems rather large, although this was considered the norm in earlier times. In fact, life was drastically different for most families and nowhere is this more evident than in the educational system. Most children attended school on an irregular basis, unless they came from a wealthy family, due to the fact that their help was needed around the house and on the farm. It was not unusual for the boys to attend school, if possible, and the young ladies were expected to stay home, learning how to take care of household duties from their mother.

This dapper gentleman, complete with a bowler hat and walking stick is most probably dressed in his Sunday best merely to have his picture taken. Most people in Petoskey and elsewhere did not have a reason, nor did they have the means to dress up on a daily basis. Despite the fact that in 1910, the cost of a suit was between $7 and $10, that was a great deal of money considering the fact that for many people it was a week's worth of wages. While wages, as well as the cost of clothing have gone up significantly since this picture was taken, many of the residents of northern Michigan still prefer dress casual attire. Of course, expectations with regards to formal wear have changed significantly since this gentleman posed for his picture.

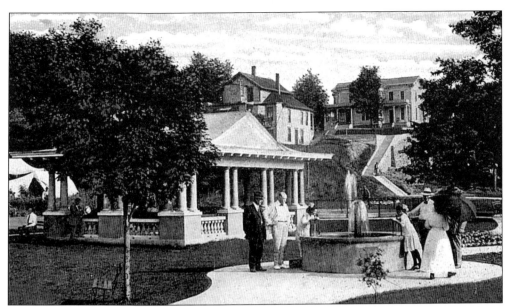

People came from all over the country to partake in the mineral waters that flowed so freely in the Petoskey area. This, the well at Mineral Wells Park in downtown Petoskey, is one of many such springs that can be found. While the GR&I Railroad was promoting itself as the "Fishing Line," just as many people were vacationing in Emmet County for the health benefits as were for the outdoors adventure. There were a number of proponents of the health benefits derived from the mineral wells, as well as the clean, fresh air that was believed to cure hay fever allergies.

When the railroads were a primary form of transportation, Marquette Park served as a "suburban" station, or a place to rest and relax. Conveniently located near the Pere Marquette Railroad Station, as well as the piers, this park offered travelers a chance to gain a positive perspective on the town upon arrival. The city of Petoskey was primarily a manufacturing town, therefore it was the sort of place that many travelers were unaccustomed to visiting. For most people who were just arriving, this was their first glimpse of the town, and for those who were departing, this would give them something positive to remember about Petoskey.

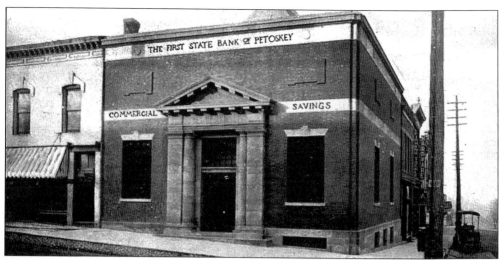

Unlike most financial institutions of its time, the First State Bank of Petoskey was both a commercial and savings bank. It was located on the corner of Lake and Howard Streets in the Historic Gaslight District, prominently situated in the middle of downtown. Merchants, tourists, and the well-to-do were able to safely deposit their money—that is, until the Great Depression. The demise of the lumber boom a few years earlier changed the economic landscape of northern Michigan forever and, within a decade, the Great Depression left many people destitute. At the same time, many businesses, including institutions such as the First State Bank of Petoskey, were forced to close their doors.

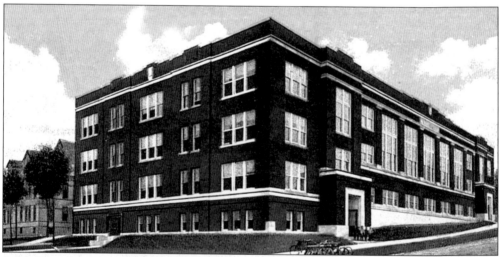

A fond memory for a number of alumni, the old high school in Petoskey has long since been replaced with a new building, now located on Hill Street. At the present time there are five elementary schools, a middle school, and two high schools in Petoskey—Concord Academy, a charter school, and Petoskey High School. The Michigan Association of Public School Academies has recognized the Concord Academy, while the Petoskey High School is a National Exemplary School. In 1998, voters in Petoskey passed a $38.5 million bond issue to expand and renovate all of the existing schools within the district. At the present time, there are over 3,000 students in the Petoskey Public Schools; approximately 1,100 of them attend Petoskey High School.

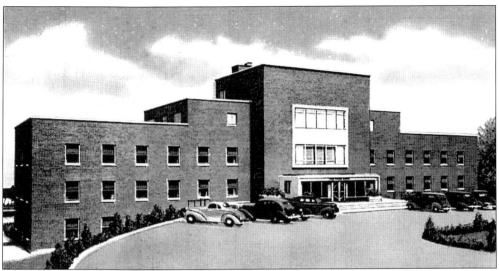

Little Traverse Hospital, once located on the south side of Petoskey, is now home to what has become Northern Michigan Hospitals. The hospital, now over 100 years old, serves more than 350,000 patients in over 24 counties. Little Traverse Hospital may have begun as little more than a rural health care facility, but over the years it has earned a reputation as a world-class regional referral facility, boasting more than 160 board-certified physicians representing almost every medical and surgical specialty. Northern Michigan Hospital's Heart and Vascular Institute has achieved a number of firsts over the years, culminating in the opening of a new Heart Center in May of 2004.

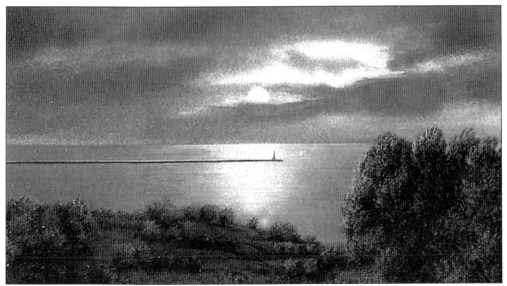

To this day, a break wall extends out into the waters of Little Traverse Bay, its light faintly shining as a beacon to approaching ships. Night has fallen on Petoskey and, to many, it is an awe-inspiring sight. Gazing out across Little Traverse Bay, the water shimmers in the moonlight and the soft breeze wafts through the trees. This is the land of the Ottawa Indians and, in time, those hearty settlers that moved to the woods of northern Michigan and built a town. From this view high upon the bluffs, it appears as though very little has changed.

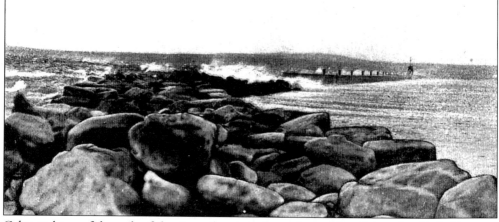

Calm and peaceful much of the time, there are those that tend to forget that Little Traverse Bay is an inlet off of Lake Michigan. The break wall that extends out from the marina in Petoskey keeps many of the waves at bay, protecting those vessels that are seeking safe harbor. When storms approach and whitecaps form, crashing onto the break wall, every sailor and fisherman knows it is best to put into port immediately, or if already docked, to secure each of the lines on the boat. It is always better to view a storm on Little Traverse Bay from shore than to try and ride it out.

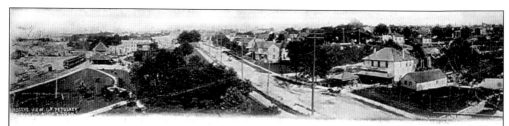

BIRD'S-EYE VIEW OF PETOSKEY, MICH.

"THERE'S ONLY ONE PETOSKEY"

OUR SLOGAN

"There's only one Petoskey,"
It's on Little Traverse' shore,
 Such fishing and such boating
Were never known before. •

 "There's only one Petoskey,"
Where the sunset's azure hue,
 Makes one feel life's worth living.

"There's only one Petoskey,"
So the tens of thousands say.
 Who come here every summer,
To pass the time away.

 All o'er our country wide,
You'll hear these thousands say,
 "There's only one Petoskey,"

Extolling the virtues of living in the Little Traverse Bay region, Petoskey as well as Bay View residents exhibit a certain degree of pride when talking about their cities. From 1926 until 1932, WBBP, a Petoskey radio station, adopted this slogan in order to instill pride in the community, and also to further the local tourist industry. While it is difficult to determine the effect that this particular postcard had on area tourism, it is relatively safe to assume that it was of a positive nature.

44

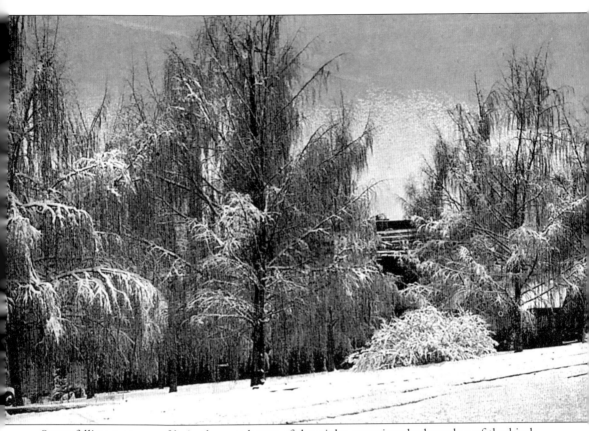

Snow falling ever so softly in the wee hours of the night, covering the branches of the birch trees and blanketing the ground below is a stark contrast to the midsummer's sun and sandcastles that once adorned the shores of Little Traverse Bay. Yet, few sights are more magnificent than the Petoskey area, or any of northern Michigan for that matter, during the winter months. Known not only for summer fun, Petoskey and the surrounding area have gained national recognition as one of America's premier winter vacation destinations. In fact, with an annual average snowfall of 117 inches, the Winter Carnival and several ski resorts within close proximity, there is something for everyone in what has been called the "Playground of the North."

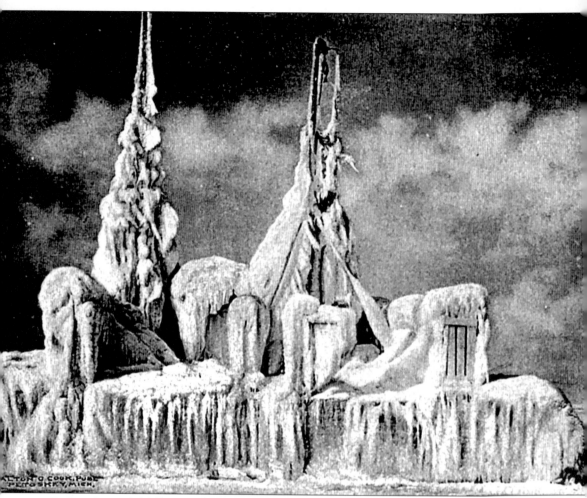

Eerie as it may initially appear, this ice cathedral formation, which envelops the breakwater on Little Traverse Bay, is but one of many gifts that the forces of nature offer up to those attending the Winter Carnival in Petoskey. While the breakwater and the lakes do not ice over as they once did, primarily as a result of global warming, sites such as this one remain commonplace not only in Petoskey, but also throughout northern Michigan. In fact, individuals willing to brave the ice during the winter months may trek out to the Petoskey Diver Memorial. The memorial, a crucifix made of Italian marble, is marked with a buoy and is located a few hundred yards east of the Petoskey Municipal Marina and north of Bay Front Park. Of course, it is always wise to check the weather forecast prior to venturing out onto Little Traverse Bay.

Blizzards in northern Michigan, like this one that took place in Petoskey during the winter of 1905, are both blessed and cursed events. While there are a number of area residents who look forward to the first snow of the season, there are also those that dread another chilling winter. A few area residents are ambivalent about the seasonal changes, although it is the snow-related sports that attract over 250,000 people to the area during the winter months. Some visitors come for the Winter Carnival, although the great majority visit the area for cross-country and downhill skiing at nearby Boyne Highlands, Boyne Mountain, and Nub's Nob. Over the years, this area has carved out a niche as the premier ski destination in the Great Lakes region.

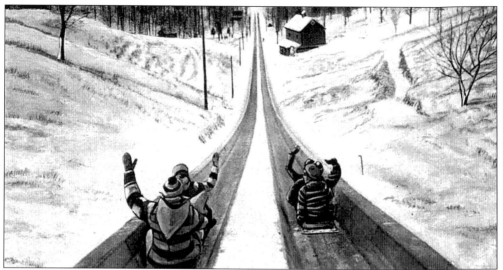

Some people know it as Winter Sports Park, and a few of Petoskey's more senior citizens remember it as City Park. To the children, and quite a few adults, it's a special place, one where they can hop on their sleds and toboggans, strap on ice skates, downhill skis, or a snowboard, and spend an afternoon with friends and family. Winter Sports Park, the site of Petoskey's annual Winter Carnival, is located just west of downtown proper, on Winter Park Lane. The park's facilities, which are free to the public, include a warming house and are lighted for use during the evening hours. Winter Sports Park may not compete with some of the area ski resorts, although it is sure to provide an afternoon of fun for the whole family.

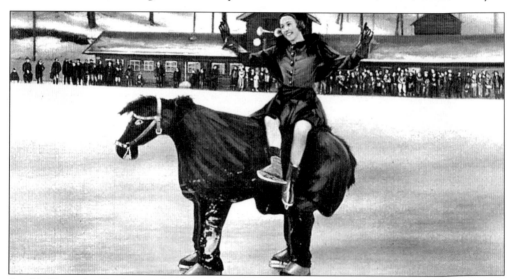

Astride Bozo the Skating Mule, this young lady poses for the crowd at the Winter Carnival in Petoskey. While it would be highly unlikely to see such a sight today, at one time, animals like Bozo were considered feature attractions at local events. The Winter Carnival has grown over the years to become one of the area's most popular events, and while animals no longer perform for show, the multitude of family-oriented functions include everything from ice skating, cross country and downhill skiing, and, of course, the ever-popular international bump jumping competition.

48

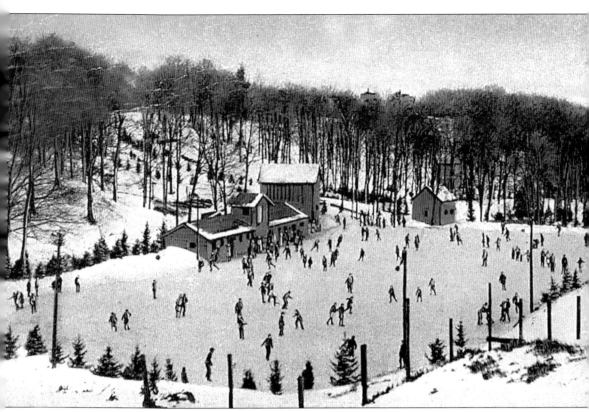

At the Winter Carnival in 1932, held at none other than Winter Sports Park, the sport of bump-jumping was invented. In this sport, a rider sits on top of a single runner sled and while going down the hill, aims for every bump. While Petoskey does plays host to the international bump-jumping competition there are numerous other activities for those individuals who are less adventurous such as ice fishing, skating, cross country skiing, hockey games and, of course, building ice castles. Most of the people pictured here appear to be braving the cold in order to do a little ice-skating.

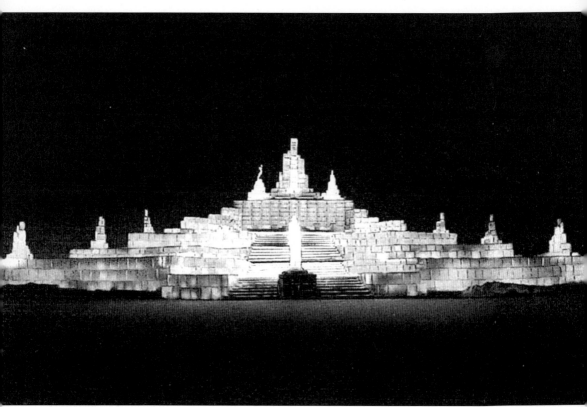

Petoskey's Winter Carnival has always been a major attraction, one that usually has a few surprises. Billed as the largest piece of solid ice sculpturing in the world at the time that it was carved, this throne was built for the Queen of the Winter Carnival. Designed and built by Stanley Kellogg, the throne was over 125 feet long, 100 feet deep, and 75 feet high, using a total of 1,300 tons of ice. The Winter Carnival, which takes place at Winter Sports Park, features sledding, skiing, sleigh rides, and games for the whole family. In Petoskey, winter is a season worth celebrating.

Three

STEAMSHIPS AND
RAILROADS

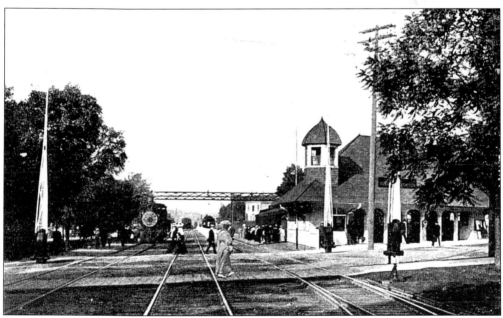

Many resort destinations, such as Petoskey, were home to two railroad depots. One of these was for year-round traffic and accommodated freight and passengers, although ones such as this GR&I Depot were known as "suburban" stations. These stations were open during the late spring, summer, and into the early fall, providing service to passengers only. Some passengers would merely transfer from the main line to a "dummy train," which would take them on a short journey to Bay View, Harbor Springs, or a similar destination. The GR&I Railroad that operated this particular depot advertised itself as "The Fishing Line."

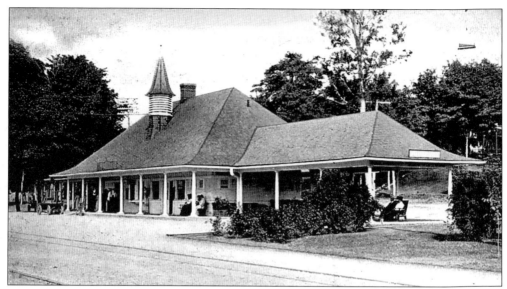

It was in May of 1874, in the midst of an economic depression, that the GR&I Railroad completed construction of track from Fife Lake to Petoskey. Shortly thereafter, with the popularity of the Methodist camp in Bay View, as well as the tourist boom in areas like Harbor Springs, Mackinaw City, Oden, and Walloon Lake, the railroad expanded to meet consumer demand.

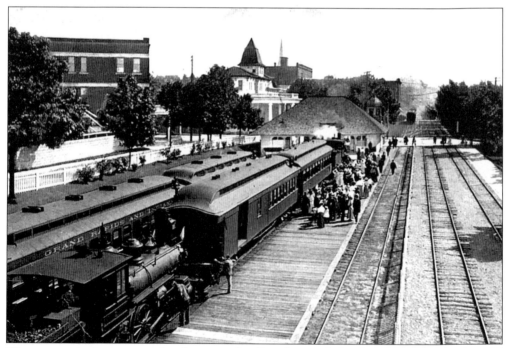

"Dummy trains" were running between the Petoskey and the Bay View depot every 20 minutes and, by 1898, the railroad was making no less than fifteen round trips between Petoskey and Bay View to Harbor Springs. The depot in Bay View, like many others located in resort communities, was a "suburban" depot and as such, was built with the comfort of its passengers in mind.

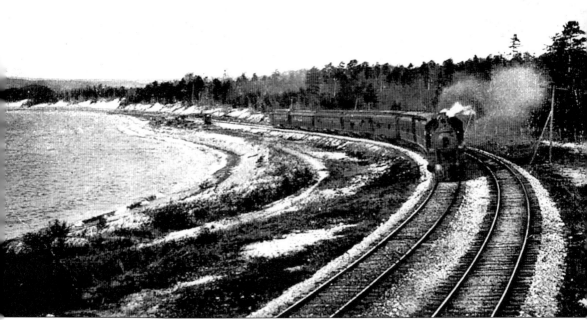

The GR&I Northland Limited, seen here passing around Little Traverse Bay near Bay View, is one of a number of lines that serviced the areas north of Petoskey. By 1898, the GR&I Northland Limited was making regular runs to Harbor Springs, including 15 round trips from Petoskey each day during the summer months, and by 1905, the line was double-tracked. The GR&I purchased this particular route, originally owned by the Bay View, Little Traverse and Harbor Springs line when the latter company filed for bankruptcy in 1888. This was the heyday of resort traffic in the Petoskey area, especially as far as the passenger trains were concerned. Summer cottages, hotels, and clubhouses had all become very popular during the summer months.

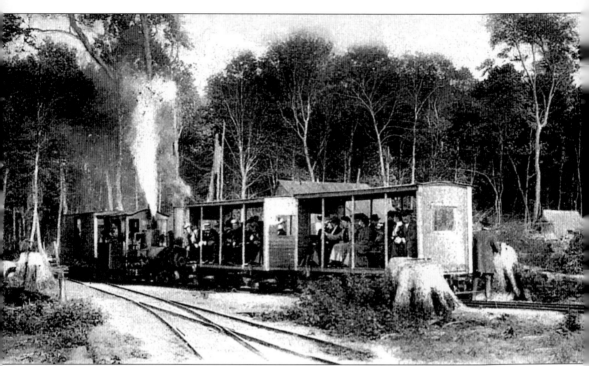

In the late 19th and early 20th century, a sense of adventure, a pioneering spirit, and, for some people, disposable income, all lead to the creation of the American vacation. For the first time, people were discovering areas such as Bay View, Harbor Springs, and Petoskey, bringing about the advent of the observation train. Some observation trains were enclosed, and others, such as the one pictured above, were open to the elements. In general, local railways owned observation trains and ran them as though they were sightseeing tours, allowing tourists the opportunity to interact with the environment. This particular line, known as the Harbor Springs Railway, followed the coast of Lake Michigan, operating between Harbor Springs and Cross Village until its demise in 1910.

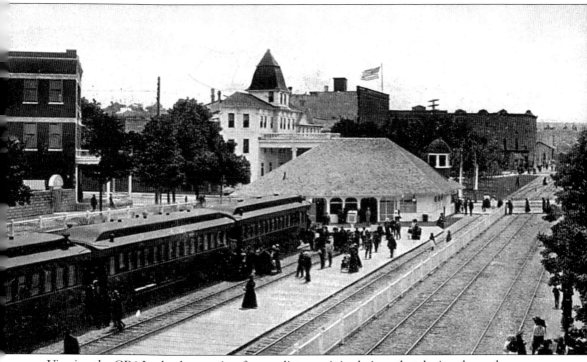

Viewing the GR&I suburban station from a distance, it is obvious that during the peak season, the railway was a hub of activity. In fact, railroad stations are, to a great degree, analogous to ports in the sense that towns tend to develop around them. Located approximately two blocks south of the main GR&I station, this "suburban" station was used primarily during the summer months, operating the trains to Walloon Lake in the south, as well as Bay View, Harbor Springs, and Alanson to the north. The depot, just off of Lake Street, provided an influx of customers and by the 1890s the core of what was to become Petoskey's Gaslight District, the "Midway," had been created.

As late as 1914, Woodlawn Avenue in Bay View remained just another dusty road in northern Michigan. Even though a number of other nearby roads were modernized and either paved or graveled, this little street was among the last to be updated. Located near the old railroad depot, in the heart of Bay View, Woodlawn Avenue is a short walk away from most of the Chautauqua-style summer homes that grace these neighborhoods. It was here at the old railroad depot where dummy trains once made frequent stops, traveling between Petoskey, Bay View, and Harbor Springs. To the west of the railroad depot are the tracks of what is now known as the Michigan Northern Railroad.

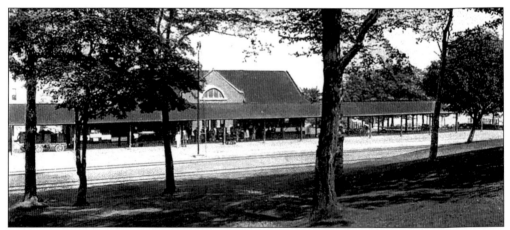

Despite the fact that the GR&I had successfully promoted the Petoskey area ever since opening the railway station in 1874—including the completion of the line from Petoskey to Mackinaw City in 1882—hard times were on the way for the railroads. By 1921, the GR&I was experiencing severe financial problems, and as a result, signed a 999 year lease with the Pennsylvania Railroad. The Pennsylvania Railroad renamed the GR&I depot, as was the custom at the time. Eventually, the Pennsylvania Railroad became PennCentral, and from 1975 until 1988, it was run by the Michigan Department of Transportation as the Michigan Northern Railway Company. This right-of-way, where the railroad once ran, is now known as the White Pine Trail.

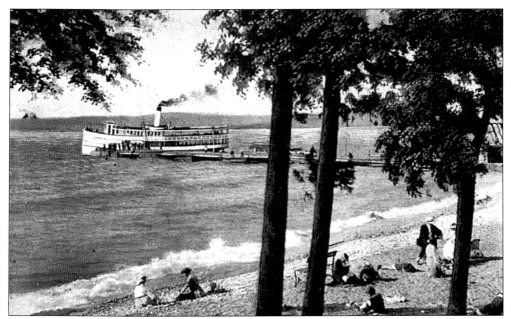

As early as the 1870s, steamships were docking at various ports of call in northern Michigan. The larger ships normally docked at Harbor Springs and Petoskey, while those with shallower drafts ferried passengers to locations such as Bay View, as well as other ports on the Inland Waterway. It was not unusual for onlookers, especially those waiting for the arrival of friends and relatives, to gather on the beach and watch the steamship dock at the pier. For the most part, the modern highway system brought about an end to not only passenger service on the Great Lakes, but also to the railroads.

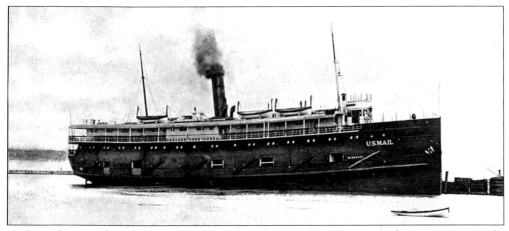

In the early part of the 20th century, one of the few reliable ways in which to transport goods, mail, or people to the Petoskey area was by ship. During this time, the S.S. *Missouri* was one of a number of ships to sail the Great Lakes performing such services. Owned by the Northern Michigan Transportation Company from 1904 until 1918, it was a ship built to weather any storm. Built by the Chicago Shipbuilding Company in 1904, the Missouri was 225 feet long, 40 feet wide, nearly 25 feet high, and could carry almost 2,500 gross tons. After going through several owners, the S.S. *Missouri* was scrapped in August of 1947. Still, there are few sights as majestic as watching a ship crash through the waves or cut its way through the ice.

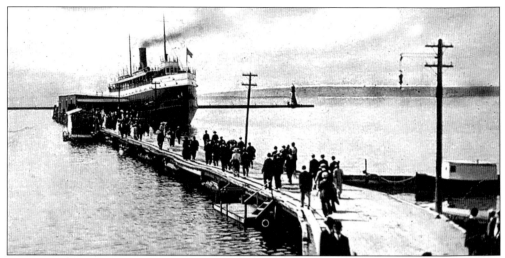

A sister ship to the S.S. *Missouri*, the Chicago Shipbuilding Company also built the S.S. *Illinois*. The S.S. *Illinois* was constructed in 1899 and began service that very same year. Also owned by the Northern Michigan Transportation Company, the *Illinois* was primarily a mail ship, but was known to carry passengers from time to time. Built of steel, the overall dimensions of the S.S. *Illinois* are virtually the same as the S.S. *Missouri*. During her tenure on the Great Lakes, no less than seven different companies owned the *Illinois*, traversing the lakes from 1899 until 1947. In July of 1947, the S.S. *Illinois* was towed down past Detroit by the tugs *Helena* and *McQueen* and scrapped by the Steel Company of Canada, Ltd. of Hamilton, Ontario.

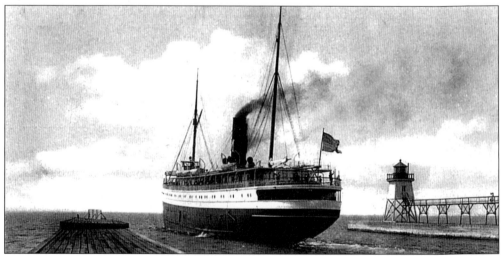

Servicing the Chicago to Mackinac Island route for close to 40 years, the S.S. *Manitou* was built in 1893 for the Lake Michigan & Lake Superior Transportation Company. More often than not, due to her size, the *Manitou* needed the assistance of a tug when visiting ports such as Charlevoix. At times, she had to be towed through Round Lake and into Lake Charlevoix, so that there was enough room to bring the ship about. The *Manitou* changed hands a number of times; in 1903 she was sold to the Manitou S.S. Company; then the Northern Michigan Transportation Company purchased her in 1908; and the Michigan Transit Company bought her in 1920. Finally, the Isle Royale Line bought the S.S. *Manitou* in 1933, changing the name of the ship to *Isle Royale*, although soon afterwards the ship experienced a fire and had to be scrapped.

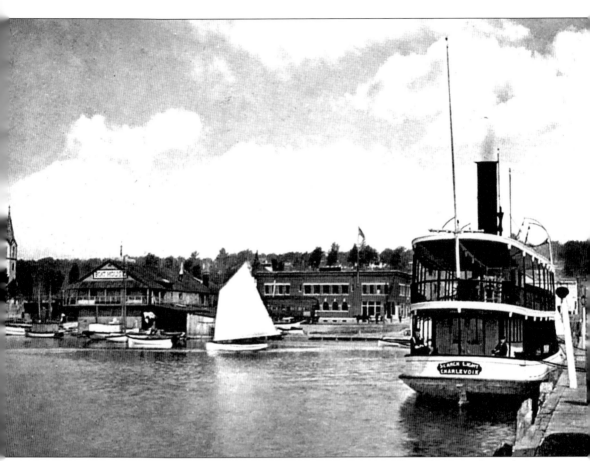

While it is generally considered bad luck to change the name of any boat, the steamship *Adrienne*, built in South Haven in 1884, had her name changed to *Search Light* when rebuilt in 1899. Known as a "ferry steamer," the *Search Light*, like her sister ship the *Silver Spray*, transported passengers between Harbor Springs, Bay View, Petoskey, and Charlevoix. The open deck on these ships allowed passengers to gain a first-hand view of the shoreline. Shown here docked at Harbor Springs, her actual homeport was Charlevoix. In 1915, following 31 years of service, the *Search Light* was scrapped. By this time, the steamship companies, both large and small, were beginning to experience financial problems similar to those of the railroads.

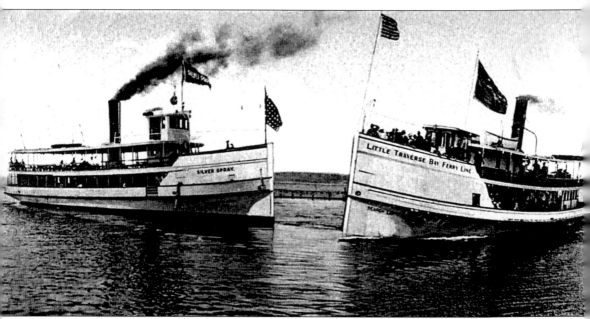

Ferry steamers were an essential form of passenger service to many of the smaller towns in northern Michigan, as well as those that either were not serviced by the railroads or had ports that were difficult to navigate. Two of the better-known of these steamships were *Adrienne* and *Bloomer Girl*, whose names were later changed to *Search Light* and *Silver Spray*. Built in South Haven (*Search Light* in 1884 and *Silver Spray* in 1894), these screw-driven steamships traversed the waters between Harbor Springs, Bay View, Petoskey, and Charlevoix. *Silver Spray* was retired from service in 1914 and, one year later, in 1915, *Search Light* was also decommissioned.

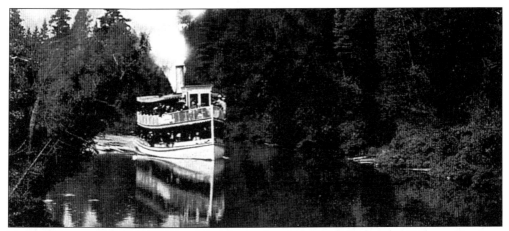

Transporting people to what were then lesser-known destinations (like Alanson, Conway, Indian River, and Oden) was one of the many services provided by the ferry steamers. The Inland Waterway, a 45-mile stretch of lakes and rivers extending from Pickerel Lake through Crooked Lake—up the Crooked River, into Burt Lake, the Indian River, Mullett Lake, the Cheboygan River and out to Lake Huron—provided the means by which tourists and early settlers visiting the Petoskey area could explore the interior of northern Michigan. Initially, the railroad lines concerned themselves only with being able to transport goods, although as the tourist trade gained in popularity, not only did the railroad companies lay track and build depots in the interior of northern Michigan, they also financed resorts and purchased ownership in a number of steamship companies.

About to dock at Bay View, this ferry steamer is likely making its way north from either Charlevoix or Petoskey. Many of the ferry steamers, such as the *Search Light* and *Silver Spray*, ran on schedules that were dependent on those of the railroads and larger steamships. Unlike their counterparts, the ferry steamers were responsible for setting sail several times per day and, having been designed with a shallow draft, these ships could travel to ports where it was not very deep. Most of the ferry steamers that sailed on the Great Lakes and Inland Waterway were screw- or propeller-driven as opposed to utilizing paddlewheels. They tended to be approximately 100 feet from bow to stern. While steamships have not graced the waters of northern Michigan for decades, resort interests in the Petoskey area plan on launching a tourist-oriented service within the next year.

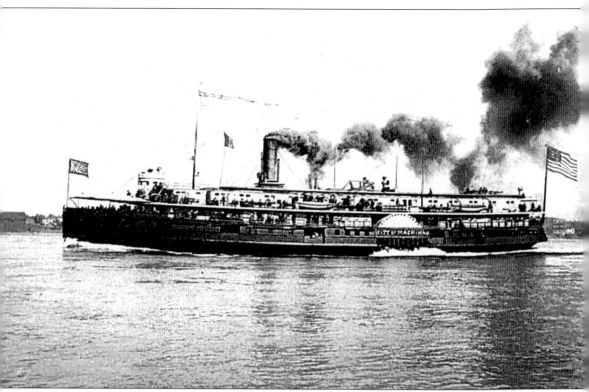

A great majority of those who came to live and vacation in Petoskey arrived either by means of the railroad or one of the many steamships that traversed the waters of Lake Michigan, although this was not always the case. There were also steamships that made regular runs between Detroit, Cleveland, and other ports on Lake Huron, primarily to Mackinaw City where passengers would disembark, only to board another ship or train, which would then take them to the Petoskey area. One of these ships was the *City of Mackinac*, a steel-hulled paddle wheeler that sailed Lake Huron from 1883 until 1932, when it was destroyed by fire. The *City of Mackinac*, remnants of which were used to build the clubhouse at the Columbia Yacht Club in Chicago, was owned by the Detroit & Cleveland Steamship Company.

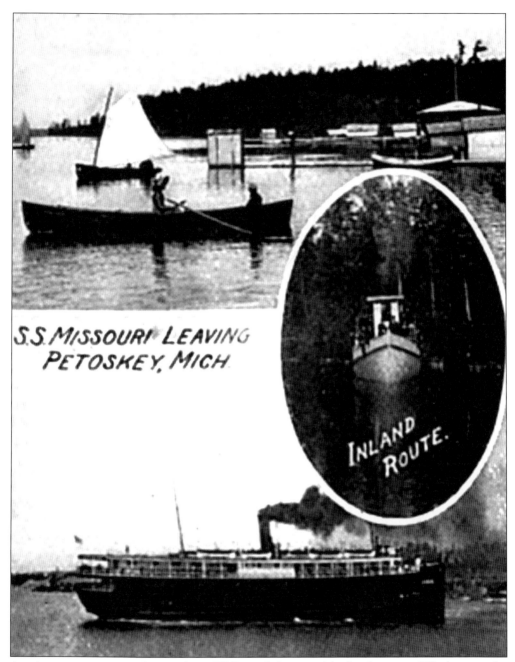

S.S. MISSOURI LEAVING
PETOSKEY, MICH.

INLAND ROUTE.

As picturesque now as it was then, Walloon Lake—to this day home to Windemere, the cottage where Ernest Hemingway spent his summers as a young man—is featured in the upper portion of this image. The lower part of the picture shows the S.S. *Missouri* leaving Petoskey, while the insert is of a ferry steamer making its way down the Inland Waterway. The Missouri was one of a number of large steamships responsible for transporting goods, as well as passengers, to the Petoskey area, although these large ships were only able to dock at ports with sufficient depth. From that point, either "dummy" trains or ferry steamers took passengers to their destinations. That is, until the advent of the automobile.

The 'clutch' works well on the road to

Petoskey

What a thrill it must have been to afford one of those newfangled jalopies, with relatively new roads to drive on and a place like Petoskey to take your sweetheart on vacation. It is no wonder that couples began to plan out vacations to more distant and exotic locations. In the early part of the 20th century, Petoskey met both of those criteria. While the Little Traverse Bay area (Bay View in particular) had been popular since the 1870s, the only methods of transportation were the railroads, steamships, or horse and buggy. The advent of the automobile rekindled the pioneer spirit. There were few destinations more scenic than Petoskey where Americans could experience the romance of the open road.

Four
BOYNE COUNTRY

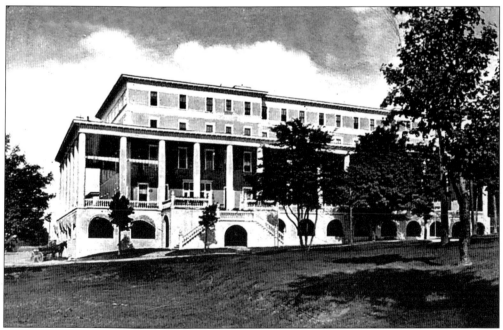

Initially, the only place in Petoskey to rent a room was a little woodshed owned by "Pa" Smith, although that all changed soon after the railroad lines came in. A veritable slew of hotels were built in and around the Petoskey area, including the Imperial Hotel, the Cushman House, the New Arlington Hotel, and the Perry Hotel, just to mention a few, as well as a number of boarding houses. Among these establishments, the Arlington Hotel stood out as the most luxurious—although not many years after being built the hotel was destroyed by fire, thus the name the New Arlington Hotel. With an expansive veranda with views of downtown Petoskey and Little Traverse Bay, as well as a convenient location, this hotel may not have been the biggest, but it was among the most popular.

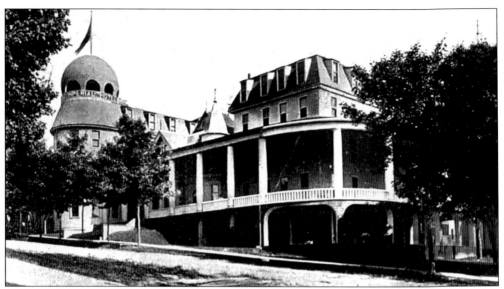

The Imperial Hotel was a mere one and a half blocks from the GR&I station, with a splendid view of Little Traverse Bay from almost every room. Known for its opulence, as were most hotels in Petoskey at the time, the Imperial Hotel was five stories high and boasted 165 rooms, half of which were equipped with steam heat. The hotel was owned by the firm of Christiancy & Howard and was considered one of the plushest hotels in northern Michigan. Featuring elevator service, sanitary plumbing, and 21 rooms with private water closets, the Imperial was a state-of-the-art hotel for its time. Room prices at the Imperial were reasonable, between $3 and $5 per day, although these prices were likely to be out of reach for most Petoskey residents.

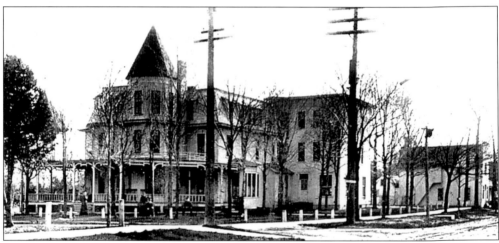

Originally named the Woodland Avenue House, J.W. Howard built the Howard House in 1886. Renovations began on the hotel about 1889, the same year that the name was changed to the Howard House. The Howard House was sold in 1901, and after changing hands several times, in 1952 the Heath family purchased and operated it as the Bay View Inn. In 1961, a young desk clerk by the name of Stafford C. Smith purchased the inn from the Heath family and began restoring the historic structure. The Bay View Inn is Victorian in almost every respect, as its previous owners would have wanted it. It is one of the few hotels in the area that has managed to survive over the years, as well as retain its charm.

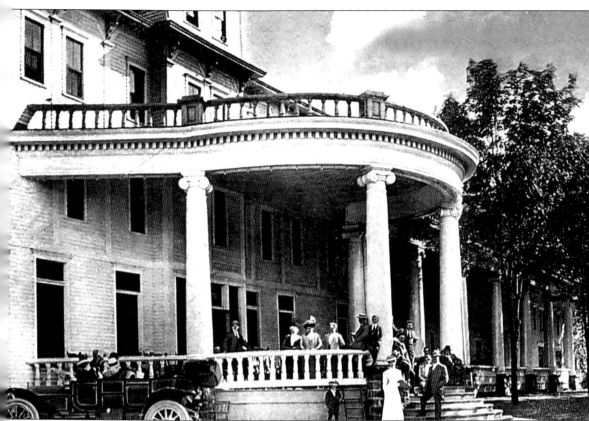

Gathering on the veranda of the Cushman House Hotel, properly-dressed ladies and gentlemen prepare for the day's festivities. When the Cushman House was first built, and during the years to follow, many of the visitors came to take part in the activities at the summer program in Bay View. There were excursions on the "dummy" trains, as well as day trips on ferry steamers—in addition to any other activities that these early tourists had on their agendas. In the days when Petoskey and Bay View were just becoming known for the healthful benefits derived from northern Michigan's clean air and the tranquility of Little Traverse Bay, the accommodations afforded guests at the Cushman House had a certain familiarity to them. As a result, the hotel became known as the "homey" Cushman House.

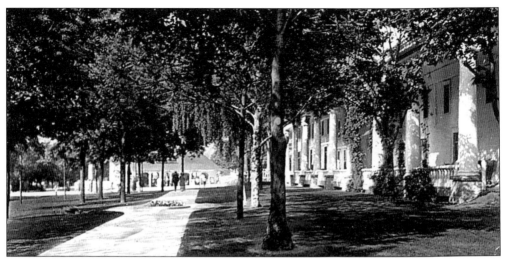

Soon after the railroad lines were completed, tourists began to flock to the Petoskey area. Until this time, there had been no need for a hotel, although it was soon evident to Dave Cushman that one should be built. By 1875, the largest hotel in northern Michigan, over 800 rooms had been built: the Cushman House. For years, the Cushman House, situated near the City Park Grill, just off of Lake Street, served as the premier hotel in Petoskey. Conveniently located in what is now the Historic Gaslight District, close to the GR&I station and overlooking Little Traverse Bay, the Cushman House provided its guests with the finest of accommodations.

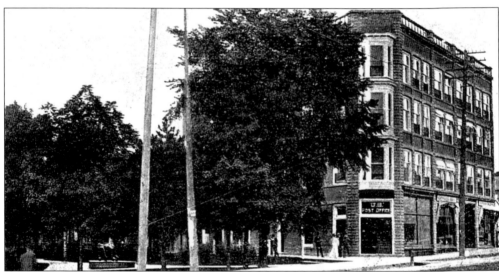

Eventually ending up in a more suitable location, the post office shown here is annexed to the Cushman House Hotel, although it had even more humble beginnings. In fact, it was the Reverend Andrew Porter who brought the first post office to what was then Bear River in 1857, subsequently naming the area Porter's Village. However, other than for Reverend Porter and his Presbyterian Indian Mission, there was precious little mail to deliver until Hazel Ingalls, the first permanent white settler, moved to the area in 1865. In time, the town and the post office were renamed Petoskey, after the Ottawa Chief who owned most of the city's land. A more modern post office, located on the corner of Petoskey and State Streets, is available to area residents.

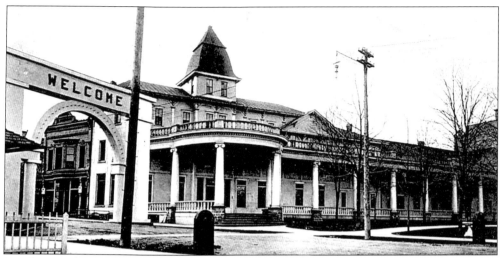

Stately in its design, the Cushman House Hotel heartily welcomed its visitors to the Petoskey area. Resorts throughout northern Michigan maintain that same degree of hospitality to this day. The Cushman House was unique in that it was one of the few hotels that featured rooms with lavish appointments such as chandeliers, carpeting, indoor plumbing, and fine dining, all with a view of Little Traverse Bay. Architecturally, the Cushman House was in keeping with its local competitors, as well as other northern Michigan resorts such as the Grand Hotel on Mackinac Island, the Omena Inn on the Leelanau Peninsula, and the Park Place in Traverse City. Of the 11 hotels that existed in the Petoskey area at the turn of the century, only the Perry Hotel and the Bay View Inn survive to this day.

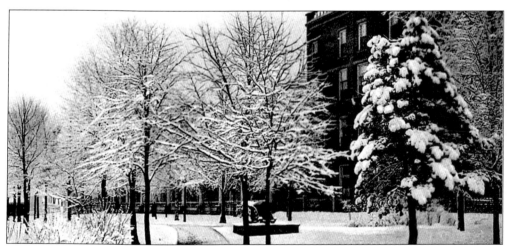

Cushman House Park, near the site of the Cushman House Hotel and postal annex, is the setting for this winter scene. Freshly fallen snow appears to have decorated the Petoskey landscape during the early morning hours, and while some of it may melt, most of the snow will remain until spring. Petoskey and the surrounding area, receives an average of 117 inches of snow per year, more than most cities in Michigan. In fact, prior to the 1940s, Petoskey was known only as a summer resort town—although with the development of several nearby ski resorts, the area now attracts more than 500,000 tourists during the winter months. Subzero winds tend to blow off of Little Traverse Bay and howl through the streets of Petoskey during winter, creating snowdrifts and making driving rather difficult.

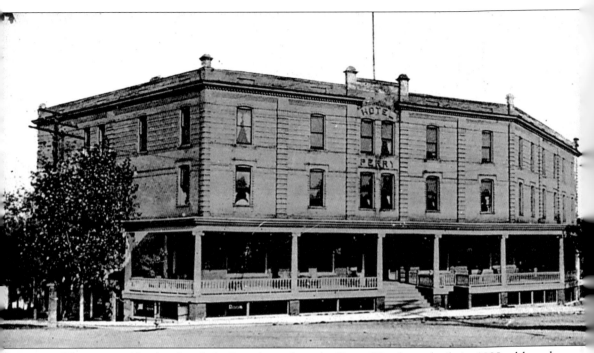

There were 11 other hotels in Petoskey when the Perry Hotel was built in 1899, although none of them were constructed of brick. In fact, the Perry Hotel, located in the Historic Gaslight District, was only the only brick hotel in town. The trend of building brick structures, which became extremely popular after a rash of fires in the early 1900s, may have started with Symon's General Store in 1879. More than merely fireproof, the Perry Hotel is a jewel among gems, with a panoramic bay window and sweeping veranda that allows visitors a breathtaking view of both 19th century Victorian homes and the surrounding landscape. Today, the same family that owns and operates the Bay View Inn operates the Perry Hotel.

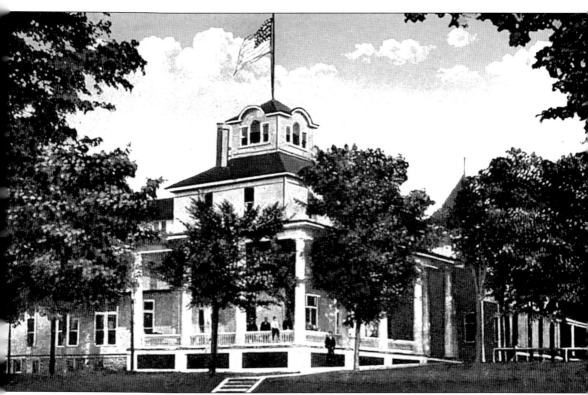

More than a mere hospitality center, Bay View House was unique in the sense that there was not a single building in Bay View at the time that could match its grandeur. Built in the 1880s, the Bay View House, was a centerpiece of the community, with its ornate gables, a sweeping wrap-around porch, and intricate woodwork representative of some of the finest architecture of the Victorian era. What started in 1875 as a simple religious retreat, when tents were erected in the vicinity of what is now the Bay View Historical Museum, had grown—and within 12 years, included over 125 cottages, a hotel, and chapel. By the 1880s, what started out as a modest six-day retreat had grown into an eight-week program known as Summer Assembly, and Bay View House had become a necessity.

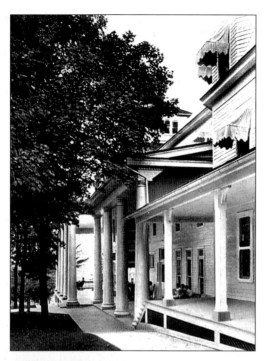

Within a few years of founding the Bay View Association in 1875, throngs of people had started to visit the area. Despite the fact that a number of hotels existed in Petoskey, one was needed to serve the residents of Bay View. Upon its completion, Bay View House became not only a hospitality center, but also the community post office. The fact is that by the late 1880s, Bay View was no longer a remote summer retreat in the north woods; the village now boasted over 125 cottages. In time, Bay View House suffered the same fate as many of the great hotels of the area, burning to the ground. When the Bay View House burned, a United States Post Office was built in its place, leaving the Bay View Inn as the only hotel in this small summer community.

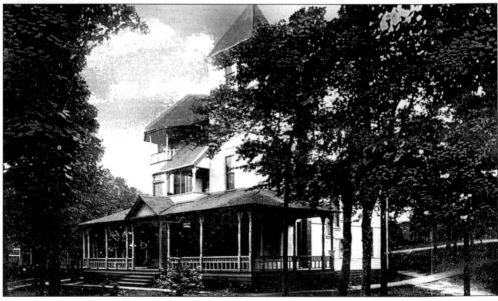

Home to faculty, as well as visiting musicians, Epworth Hall is located on Springside Avenue in Bay View. Education, whether it is of an artistic, intellectual, or spiritual nature, has always been at the center of life in this community. Few people outside of Bay View are aware that a "university" of sorts was established there as early as 1886, one which lead to the creation of the Summer Assembly program, as well as the Conservatory of Music. Much to the surprise of even some area residents, the Bay View Music Festival is America's oldest music festival still in existence. Literally thousands of people travel to northwest Michigan each summer to attend the concerts at Bay View.

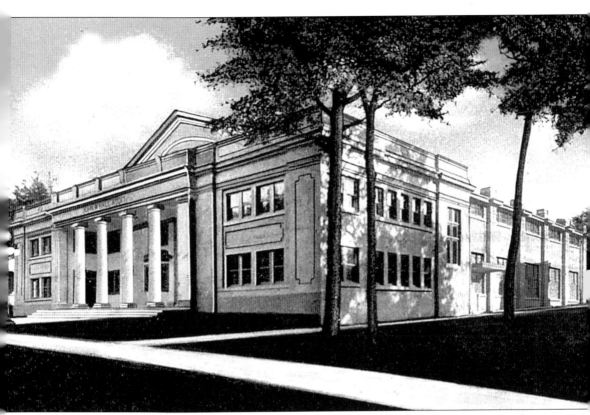

The John M. Hall Auditorium, home to not only the Bay View Music Festival, but also the Conservatory of Music, Theatre Arts Department, and Sunday Vespers Concerts, has the capacity to seat over 1,800 people. Bay View residents, tourists, and locals from the surrounding area attend performances given by both artists and students. In general, Voorhies Hall is used for smaller functions such as operas, solo recitals, and theater productions, while the music room at Crist Hall is the site of numerous chamber music concerts. Each year, thousands of guests attend concerts at Bay View; many of them come for the Sunday Vesper Concerts and the Crouse Visiting Artists Concert series.

The Grounds and Association Building, located near where Sunday services once took place, is now home to the Bay View Historical Museum. The museum actually is housed in two buildings, where both historical and archival collections are preserved. The purpose of the museum is to show how the first settlers lived, what activities they were involved in, and what cottage life was like in the 1870s. Touring the museum and strolling the grounds, it is easy to envision the Bay View Reading Circle hosting the likes of Helen Keller, Booker T. Washington, and William Jennings Bryan. Some present-day residents can trace their heritage back six generations, to Bay View's beginnings. In 1987, Bay View was designated a National Historical Landmark, one of 34 such sites in the entire state.

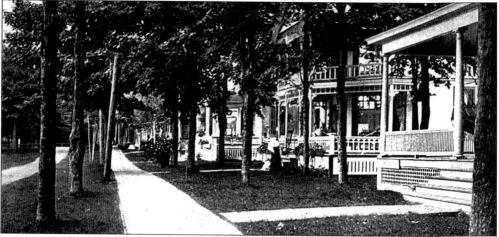

A stroll down Fairview Avenue, or any of the streets in Bay View, is akin to taking a step back in time. Cottages with expansive porches and intricate woodwork and quiet, tree-lined streets give a small glimpse of what Bay View is today. This Victorian-style community started out as a Methodist retreat, and still has deep religious roots. But science, literature, and the arts have all become part of the summer program offered at Bay View. Academic institutions such as Albion College, which held summer sessions at Bay View from 1918 until 1969—and more recently, Alma College—have had a positive influence on the stability and growth of the community. More importantly, generations of Bay View residents have helped retain its beauty and innocence.

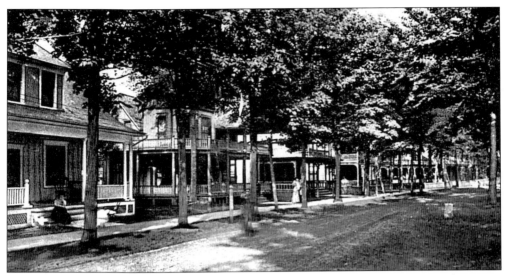

Park Avenue in Bay View, located just off of Little Traverse Bay and to the south of Tannery Creek, is lined with Chautauqua or Gingerbread-style homes. Originally known as Carpenter Gothic, this particular style was introduced to northern Michigan by members of the Methodist Church who founded a summer retreat in 1875. Several factors made Bay View the perfect venue for the educational and spiritual programs offered by the church: the northern Michigan climate, at least during the summer months, the location on Little Traverse Bay, and the ease of access as a result of the recently opened railroad. Few people could have guessed that from a mere 20 cottages built by 1877, there would end up being over 440 of them by the turn of the 19th century.

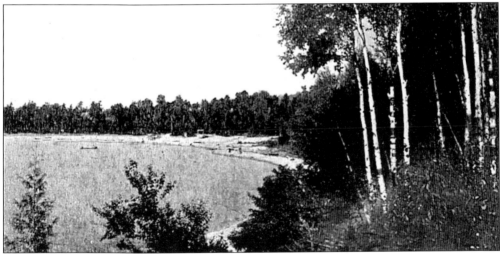

Stately white birches grace the shoreline of Little Traverse Bay, all the way from Bay View and Petoskey to Harbor Springs and further north. Considering the fact that the logging industry was so prevalent in this area, some people find it surprising that there are so many mature trees. The white birch matures in less than 75 years and has been known to grow up to 80 feet in height. Known by some as the canoe birch or paper birch, its thin bark was used by the Indians to build canoes and use as writing paper. The sap from birch trees can also be used to make herbal medicines or syrup. For most people, the white birches of Bay View merely provide a stunning backdrop to the beauty of Little Traverse Bay.

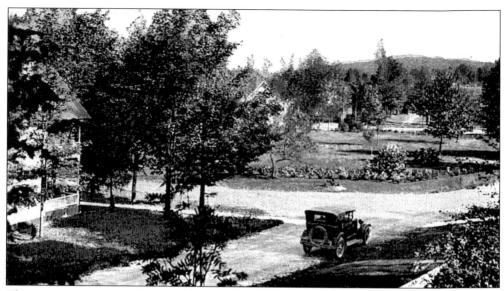

There are many people who would contend that Bay View itself is a community with a park-like atmosphere. Aside from the private beach located on Little Traverse Bay, the summer community is also within walking distance of Bayfront Park. There are a number of seasonal programs offered each year such as swimming, sailing, tennis, and camping, all of which are lead or taught by certified instructors. Regarding recreation the Bay View Association has adopted the aim "Fun, Recreation and Growth for All." The recreational programs at Bay View are designed not only for children, but also for the young at heart.

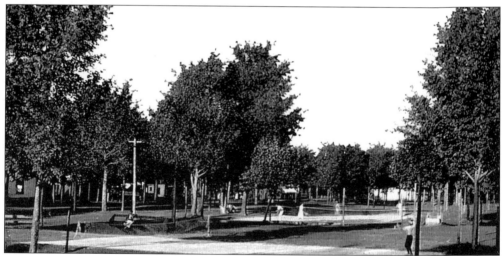

Residents of Bay View are active and family-oriented, and this is no more evident than at the Tennis Club. While there are a number of recreational programs from golf to sailing and swimming, virtually every day of the week there is a tennis tournament of one sort or another. From the beginning of June, when the Tennis Club first meets, through the middle of August, there are singles, doubles, and mixed tournaments planned for both men and women, as well as for children of all ages. Tree-lined and secluded, the tennis courts are nestled among Victorian-era cottages, most of which had been built by the turn of the 19th century.

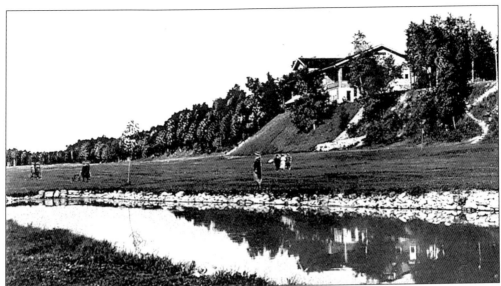

Bordered on the north by Tannery Creek, the Petoskey and Bay View Country Club is a private 18-hole golf course which offers its members the chance to play a myriad of dogleg fairways, right and left, and also a terrific view of Little Traverse Bay from virtually every vantage point on the course. Classically-designed at the turn of the century, the club features narrow tree-lined fairways, exceedingly small putting surfaces, and a heavy rough. The club, one of 19 courses in Emmet County, is open to members from May 1st until October 31st each year.

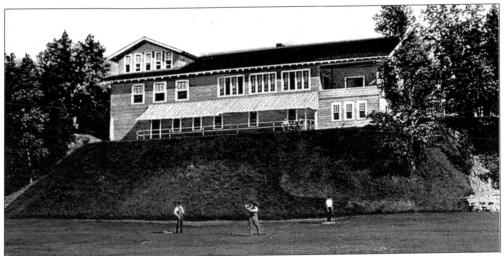

Tight fairways, heavy roughs, and rather unforgiving greens, not to mention a view of the cool, refreshing waters of Little Traverse Bay, are only a few of the many problems facing these golfers as they attempt to play golf at the Petoskey and Bay View Country Club. The Petoskey and Bay View Country Club, has become an institution over the years. Frequently used by club members for everything from anniversary parties to wedding receptions, the club has gained a reputation that is unequaled by its peers. Golf is a sport that has grown in popularity over the past decade and nowhere is this more evident than in northern Michigan, where there are close to 100 golf courses, yet few of them can match the charm of the Petoskey and Bay View Country Club.

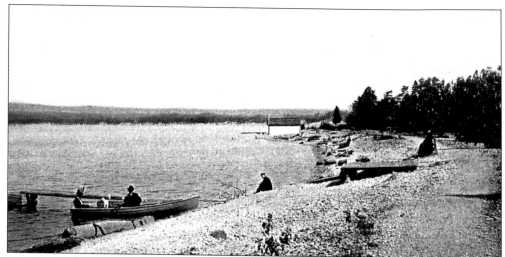

Given an idyllic location on the sandy shores of Little Traverse Bay, few activities could be more relaxing than spending the day on the beach at Bay View. Whether sifting through the pebbles for Petoskey stones, going for an afternoon swim, or taking out the rowboat and trying to catch the "one that got away," none of these opportunities should ever be passed up. During the summer months, it is highly unlikely that this beach would be as unpopulated as it appears here, especially with all of the programs and activities planned by the Bay View Association. These serene long stretches of beach have earned both Bay View and Petoskey well-deserved reputations.

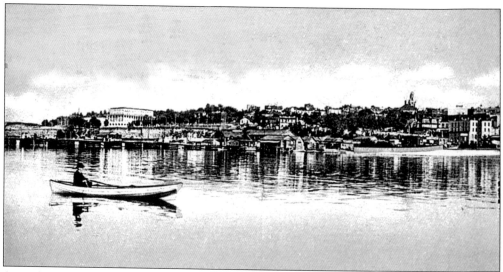

According to the note on this postcard, the writer intends on arriving in Escanaba within a couple of days. It is entirely possible that, if this person had actually launched a skiff and went rowing for an afternoon, they may have changed their travel plans. Given the beauty of Little Traverse Bay and the entire Petoskey area, many visitors tend to stay longer than initially expected. While Petoskey itself was as much a manufacturing town as it was a tourist destination at the turn of the 19th century, the residents of nearby Bay View had already let it be known what they thought of the area. It was already evident that as the logging industry was becoming less and less profitable, another industry would need to take its place.

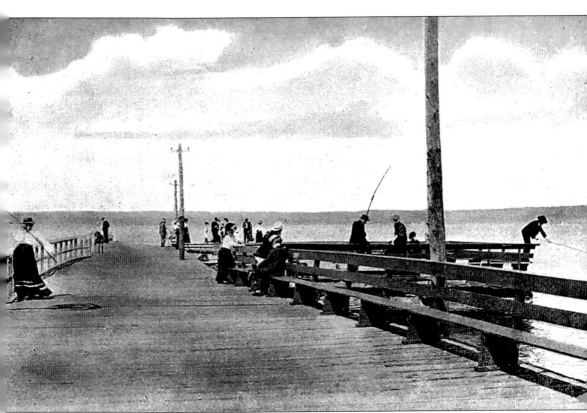

Fishing off of the pier in Bay View did not necessarily offer the solitude that some fishermen experience in other locations, although it was truly a family-oriented activity. Men, women, and children would gather on the dock in an attempt to catch one of the many bass, bluegill, perch, or trout that inhabit the waters of Little Traverse Bay. While not many women are seen wearing dresses when fishing these days, nor men and boys in suits, fishing remains one of the most popular pastimes in the area. Probably one of the most distinctive features of this dock is that benches were incorporated into the design. Due to the fact that ships arrived on a daily basis during the summer, they were originally built for the comfort of the passengers.

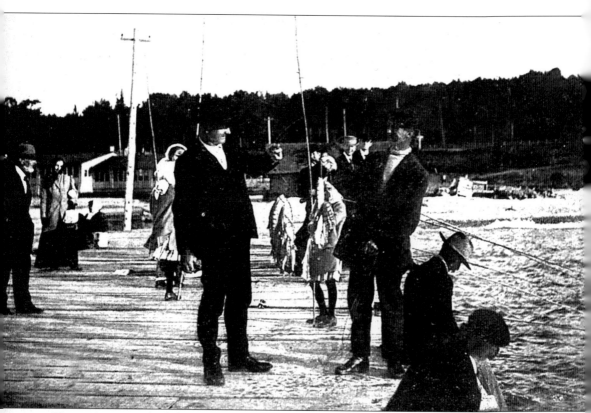

Times change, and while it is highly unlikely that a number of people would gather in dress clothes to go fishing these days, quite a few anglers do still gather on the shore and docks to try their luck at catching any one of a number of pan fish. Historically, one of the most popular of these sport fish has been the lake perch. Normally found within 30 feet of the shore, lake perch feed year round, making them a favorite among ice fishermen. Traditionally valued for their white, flaky meat, the perch population in Lake Michigan has drastically declined in recent years and there are now new regulations, both commercial and sport, regarding the lake perch. No matter what season, fishermen can still be seen attempting to catch their limit of lake perch out on Little Traverse Bay.

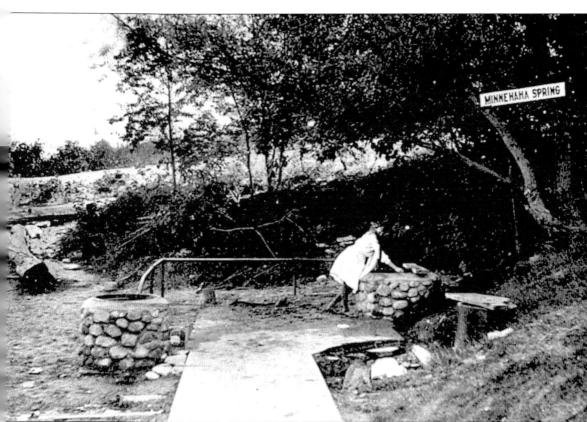

One of the many reasons that people initially made the arduous journey to Bay View in the latter part of the 19th century, in addition to the clean air, natural setting, and camp meetings, were the artesian springs that flowed freely throughout the entire area. One of the artesian springs in Bay View is Minnehaha Springs, named after the wife of the character Hiawatha in the poem, *The Song of Hiawatha* by Henry Wadsworth Longfellow. While it may not have occurred to this young lady as she drew water, artesian springs are defined by the fact that the water flows through a natural rock formation that lies above the existing water table. They are common throughout all of northern Michigan.

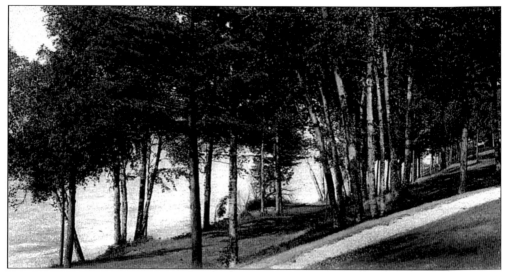

Both white birches and river birches grow well in northern Michigan, primarily due to the moistness of the soil and the fair amount of precipitation in the area. While not as undeveloped today, there are still stretches of woods leading down to the beach in Bay View and many of the other nearby communities. Needing only partial sunlight to exist, birch trees can grow anywhere from 40 to 80 feet in height at maturity, depending on the species. While there may be numerous uses for everything from the sap to the bark, most people would probably agree that, at least these days, their natural beauty is sought after the most. Walking among the birches, down one of the many paths that lead to the beach at Little Traverse Bay, is an unforgettable experience.

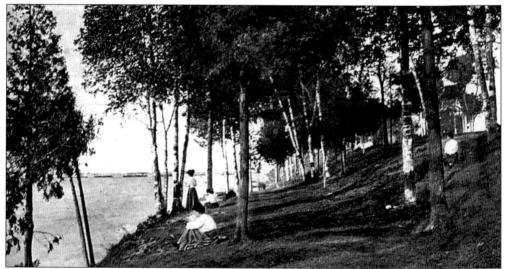

Groves of pines and birches line the pathways that lead from the summer homes at Bay View down to the beach and Little Traverse Bay. There was a time when residents of this quaint community would sit and watch the steamers and ferries pass by on their way to one of the many ports of call on the Great Lakes. These days, the bluffs overlooking Little Traverse Bay are still peaceful and serene, yet the only passing ships are likely to be those of recreational boaters on their way to Petoskey, Harbor Springs, or Harbor Point.

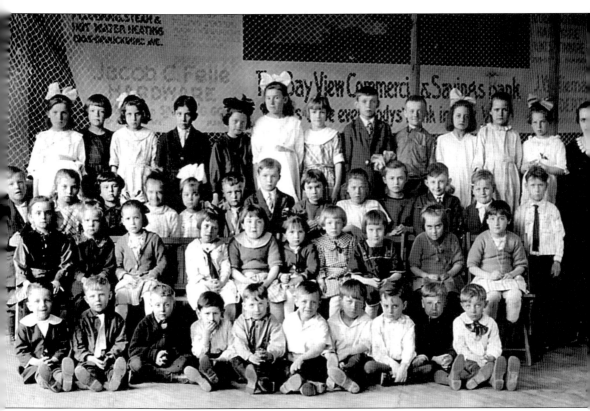

The Bay View Summer Assembly includes a number of recreational and cultural programs designed for children, as well as young adults. The programs at Bay View are designed to promote awareness of intellectual, scientific, and cultural discovery within the context of a religious and moral framework. In particular, Bay View is known for its music, theater, and arts programs that have attracted guest artists and speakers since its inception in 1875. Initially founded by Methodists, Bay View began as a Chautauqua-style camp meeting, evolving into a resort community of over 400 summer homes. The Bay View community was designated a National Historic Landmark in 1987.

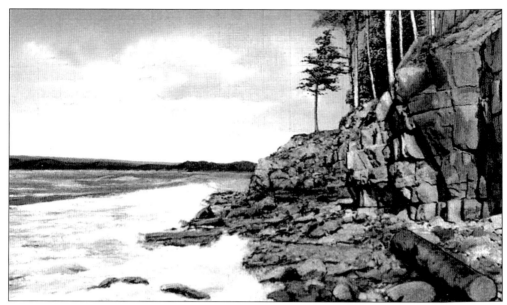

It is possible to view the waters of Little Traverse Bay from the porch of virtually any one of the terraced summer homes in Bay View. In fact, it is only a short walk down past the birches and pines to the craggy rocks and beach that make up much of the shoreline. The water is refreshing; the breeze coming in off the bay is soft and gentle and the view is spectacular. It is no wonder that this area has been a favorite—of the Ottawa, the early settlers, and today's tourists.

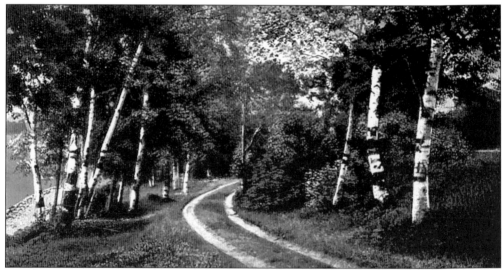

As the frost begins to set in, the leaves on the beeches, birches, and maples of northern Michigan seem to come alive with color. Few activities can compare with taking a drive down a country lane or walk through the woods in the autumn, and while the vibrant hues of orange, red, and yellow may only last a short time before the leaves fall, it is a sure sign that winter is just around the corner. This time of year is one of bittersweet emotion throughout all of northern Michigan, yet this is particularly true in Bay View. Now, as the residents of Bay View begin to shutter up their cottages in preparation for winter, locals in nearby communities are getting ready for the onslaught of winter tourists.

Five

PLEASANT
SURROUNDINGS

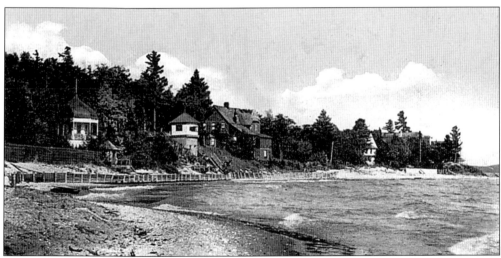

Cottages and summer homes vary in size, style, and price range, although a visit to Harbor Point will very likely support the notion that bigger is better. In the age of the industrialists, around the turn of the 19th century, cottages, homes, and hotels were all designed with style and grandeur. Nowhere is this more obvious than at Harbor Point, where summer homes are nestled among the trees, their ornate facades facing the beach, and in some cases, their gables rising above the tree line.

Harbor Point, known as a place where the wealthy can enjoy anonymity and seclusion, is located approximately one-half mile southwest of Harbor Springs. Harbor Point served a playground of families such as the Fords, Gambles, and Upjohns—in an area that, other than for the handful of summer homes built on this peninsula, remained untouched over the years. At one time, it was possible to walk down to the beach and view the passenger ships as they passed around the point on their way to Mackinac Island. Today, while the walkways down to the beach still exist and many of the original families still vacation in the summer at Harbor Point, the whistling of the wind through the trees has replaced the sound of the ships' bells.

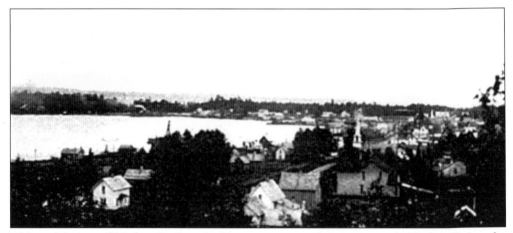

This aerial view of Harbor Springs, looking west across the port towards Harbor Point, the church steeple rising up above the other buildings, shows the town in its entirety. While Harbor Springs may have the deepest port of any of the towns in northern Michigan, it is difficult to envision this resort village as home to one of the busiest seafaring ports in the state. Aside from the timber industry and commercial fishing that took place in Harbor Springs, many of the larger passenger ships bound for Bay View and Petoskey found it easier to dock in this port merely due to the depth of its waters. Initially founded by Jesuit missionaries, the town was first called L' Arbre Croche, meaning Crooked Tree, although French traders eventually renamed it Petit Traverse, or Little Traverse. In 1880, the village was incorporated as Harbor Springs.

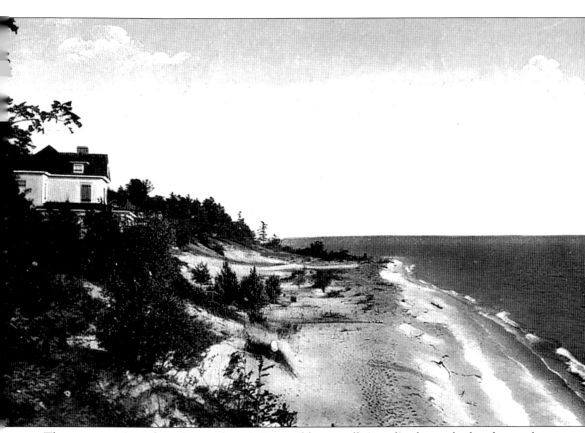

There are precious few places where it is possible to walk in solitude on the beach, watch sailboats as they round the point in the Chicago to Mackinac Race, and then walk inland a few blocks to an old-fashioned ice cream parlor. The beach at Harbor Springs is a fabled stretch of sand where all three are possible. Away from the city lights, one can gain a view of the Northern Lights in the summer evening sky.

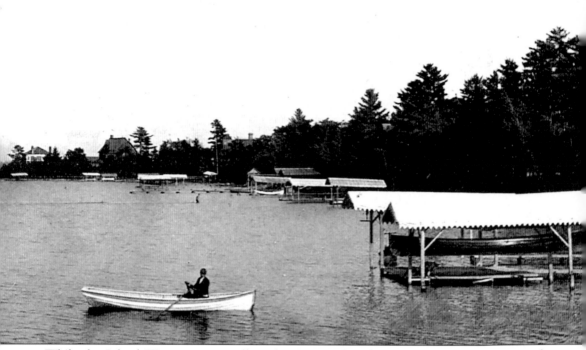

While the Inland Waterways, as well as the Great Lakes, have been a primary source of transportation for hundreds of years, it wasn't until the latter part of the 19th century that boating came to be regarded as a leisure activity. Away from all of the hustle and bustle of city life, few things were more peaceful and relaxing than to rowing a boat out onto Little Traverse Bay. By the look of all the boathouses lining the shore, in 1909, Harbor Point was one of those places where people could get away from it all. While the size, styles, and types of boats and boathouses may have changed over the decades, Harbor Point remains much the same as it was at the turn of the century.

There are some areas along the shores of Little Traverse Bay, such as this area near Harbor Point, where it is rather difficult to find the beach merely due to the intense undergrowth. In a number of cases, the roads, walkways, and resting places that were built on the shoreline did nothing more than obscure the view, although there are points along the beachfront where they make perfectly good sense. Members of the Harbor Point Association designed and built a number of walkways and resting areas, most of which tend to be located on the bluffs that rise steeply up from Little Traverse Bay. These areas not only allow residents to walk safely along the bluffs without fear of sliding down the hill, but also put a safe distance between them and the ever-present poison ivy.

Acting on the notion that everything, including the natural surroundings, can be improved upon, vacationers at a number of resort communities built roads and walkways next to the beach. At one time, Harbor Point featured a wooden walkway that followed the contour of the beach. Of course, this was in addition to the summer homes, docks, and boathouses that took up space on the beach. Both difficult and expensive to maintain, especially given the harshness of the northern Michigan winters, the walkways were eventually removed from a number of beach areas. The shoreline at Harbor Point remains, for the most part, an uncluttered stretch of Lake Michigan, except for the occasional piece of driftwood.

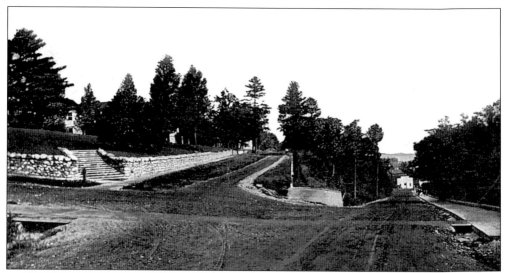

Leading up to the Overlook, Bluff Road in Harbor Springs is one of the highest elevations in town. From this vantage point, it is possible to see not only Harbor Springs and Harbor Point, but also a magnificent view of Petoskey across Little Traverse Bay. Bluff Road ascends to the Overlook in the center of downtown Harbor Springs. The town takes on a unique character from the Overlook, although the budding trees in the spring and vibrant colors of the northern Michigan autumns tend to make this a very popular spot. Whether gazing at the stars or watching the sailboats as they criss-cross Little Traverse Bay, no trip to Harbor Springs is complete without a visit to the Overlook.

Indian Head, one of the many small creeks in the Harbor Springs area, teems with brown trout and rainbow trout. A favorite among fishermen, Indian Head is one of many such waterways throughout Emmet County, most of them perfect for the early morning angler. Emmet County has numerous creeks and riverbeds, the larger ones being the Bear River, Crooked River, and the Maple River. There are some smaller creeks close to the Harbor Springs area such as Five Mile Creek, McPhee Creek, and Sanford Creek.

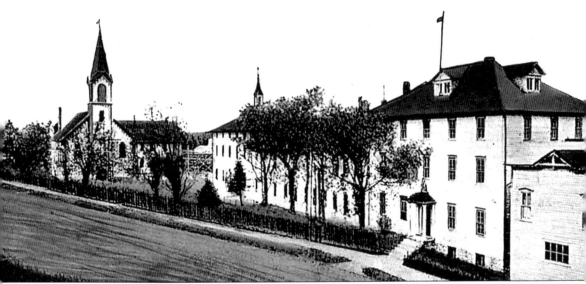

As early as 1823, the Ottawa Indians petitioned President Monroe and the United States Congress for a "teacher of the gospel" in the Harbor Springs and Petoskey area, although it was not until 1829 that a school was built. The new school, along with the church and rectory, were finished in the fall of that year. The initial enrollment included 13 day students and 25 boarders. The Holy Childhood Church and the Indian Mission in Harbor Springs were the result of a great deal of planning and hard work, not only by the Ottawa, but also by Father Peter De Jean and the local settlers. While the Indian Mission has undergone a great many changes over the years, it is currently in use as Holy Childhood Day Care Center, and the original structure still stands on Main Street in Harbor Springs.

Roaring Brook, its waters seemingly rushing out of nowhere, flowing through the dense vegetation and primitive undergrowth, is a prime example of the many natural wonders found in and around the Petoskey area. About eight miles northwest of Petoskey, a slight diversion off the road to Harbor Springs, is a wooded area full of fallen cedars. Here the waters of Roaring Brook tumble down over the rocks. For the most part, the area is now as it has been for centuries, due in great part to the resourcefulness and farsightedness of local residents. There is a footpath at Roaring Brook which leads to a hilltop. From here it is possible to gaze down upon much of the forest and out over the waters of Little Traverse Bay.

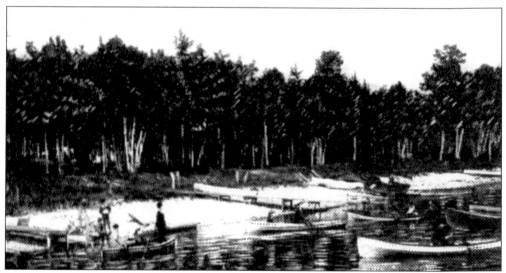

Wequetonsing, a resort area founded by an association of Presbyterians in 1878, is a wooded natural area on the shores of Little Traverse Bay. The beach is pristine and uncluttered except for the occasional rowboat or sailboat. Located approximately one mile east of Harbor Springs, and just off of M-119, at one time Wequetonsing was well-known not only for its beauty, but also the artesian springs. The beach at Wequetonsing has been a favorite among swimmers and boaters since the early days. At the beginning of the 20th century, it was almost as crowded as it is today. Visitors back then stayed at the Ramona Park Hotel, a summer-only resort just down the street. It is now known as the Harbour Inn, and operates on a year-round basis.

This young lady, like so many others during the Petoskey area's early days, appears to be taking advantage of an artesian well at Wequetonsing. Wequetonsing, a Presbyterian resort just east of Harbor Springs, was popular for both its healthful summer climate and its artesian springs (which also flowed freely in other nearby areas). The resort at Wequetonsing was established by a group of Presbyterians in 1878, for many of the same reasons as Bay View. Similar to other resorts that were founded in the latter part of the 19th century, Wequetonsing focused on ensuring that its members had a relatively inexpensive, pleasing, and healthful setting where they could enjoy the summer months. The resort name is taken from the Indian word for the bay upon which Harbor Springs is situated.

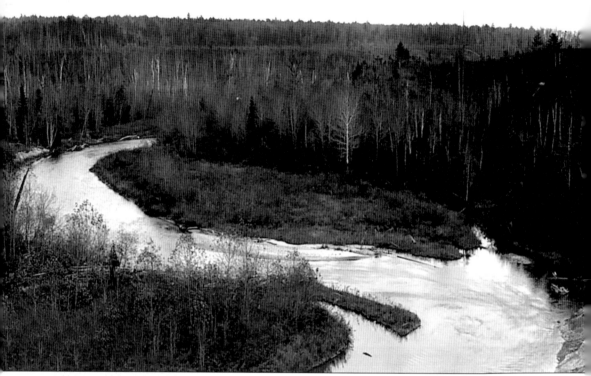

The Big Pigeon River near Indian River, while located in Cheboygan rather than Emmet County, is a part of the Inland Waterway. By using the Inland Waterway, it was possible for Indians and fur traders to portage their boats from Little Traverse Bay to Crooked Lake, then they could paddle up the Crooked River to Burt Lake, the Indian River, Mullett Lake, and the Cheboygan River, all the way to Lake Huron on the east side of the state. If it were not for the Inland Waterway, the natives and early settlers would have been forced either to portage their canoes across the state or paddle them around the Straits of Mackinac. At one time, ferry steamers ran excursions and limited passenger service on the Inland Waterway. These days, families take weekend long trips down the waterway, picnicking, camping, and fishing along the 150 miles of shoreline.

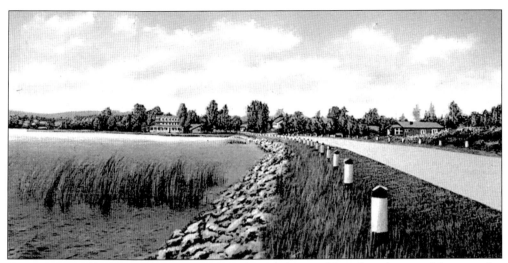

Conway, a small village located about six miles northeast of Petoskey, is one of those quaint towns located in rural Emmet County. Situated on the west end of Crooked Lake, Conway is well-known among fishermen as the home of a wide variety of bass, as well as bluegill, muskellunge, walleye, yellow perch, northern pike, walleye, and trout. The fish hatchery in nearby Oden, on the north shore of Crooked Lake, may explain the diverse and plentiful fish population. The beach frontage and docking facilities in Conway, all on Crooked Lake, allow for boaters to launch their crafts and spend an afternoon on the Inland Waterway.

Like many other towns in northern Michigan, Wolverine began as a lumber town. Founded by John M. Sanborn and Daniel McKillop, the town was originally known as Torrey until it received its first post office in 1882. Wolverine, in its early days, was one of the main hubs of the Michigan Central Railroad and home to a number of resorts. Like many other places in northern Michigan, the town was also home to several summer camps—among them was the Rainbow Camp, which assisted families and served as a summer retreat for children. The lumber boom may be nothing more than a faint memory, yet the resorts and camps of Wolverine and the surrounding area remain popular to this day. In particular, Wolverine is known as a haven for sport fishermen, hunters, and those seeking to get away from it all.

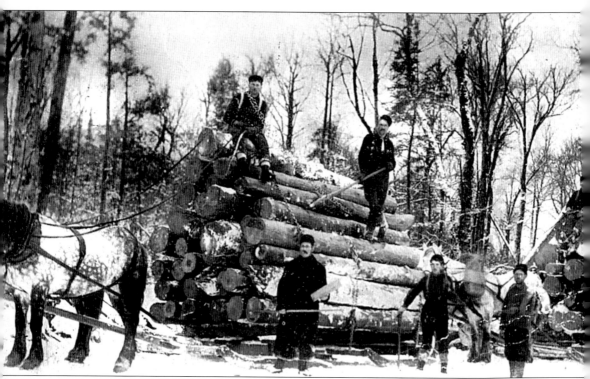

During the winter months, the lakes and rivers filled with ice, making it all but impossible to drive logs down the waterway to the mill. In fact, the more timber that was cut, the further it ended up from the waterways. This posed a real problem, and the solution was to haul the lumber on horse-drawn sleds. Most of the men employed as lumberjacks worked long hours and earned a pittance considering the conditions that they endured. In the 1880s and 1890s, the average wage for a lumberjack was around $20 to $25 per month, including room and board. Working conditions for these lumberjacks, from the Wolverine area, were similar to those of the other northern Michigan logging camps.

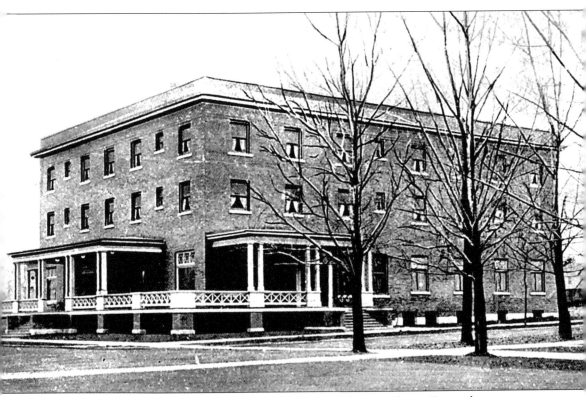

The Wolverine Hotel is listed on the National Register of Historic Places. Known by some as the Dilworth Hotel or the Wolverine-Dilworth Hotel, it is located on Water Street in downtown Boyne City. It was designed by the Price Brothers in Classical Revival style at the turn of the 19th century. The hotel, built of bricks from the Boyne City Clay Products Company, was owned by W.S. Shaw, and featured four executive suites and 20 guest rooms, as well as conference and banquet facilities. It was known for providing its patrons with first-class service, was most prosperous from the early 1900s until the late 1920s. Having fallen into disrepair over the years, the hotel is currently undergoing renovation.

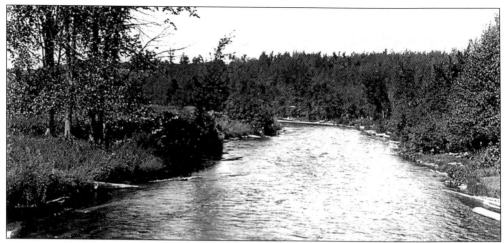

By an Act of Congress in 1992, the Sturgeon River was designated a National Wild and Scenic River. Known by recreational fishermen for its bountiful supply of brown trout, steelhead, and salmon, there are two sets of rapids on the Sturgeon River that present a unique challenge for those who choose to canoe or kayak down this waterway. The Sturgeon River bends and curves its way from Wolverine to Indian River, where it flows into Burt Lake. At this point, it is possible to follow one of two paths: the Indian River to Mullett Lake, onto the Cheboygan River and Lake Huron, or the Inland Waterway to Petoskey. Preserved for future generations, the habitat, wildlife and beauty of the Sturgeon River remain untouched by modern development.

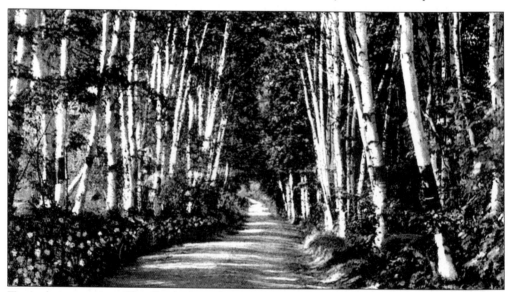

Topinabee, a quaint village located on the shores of Mullett Lake, is approximately 27 miles east of Petoskey. One of the smaller villages in Cheboygan County, it is as popular with tourists today as it was with lumbermen at the turn of the century. Initially a company town, Topinabee was founded by executives from the Michigan Central Railroad in 1881. Shortly thereafter, H.H. Pike assisted in platting the village. Pike, who also owned the first resort in Topinabee, was instrumental in naming the village. It is named after a Potawattomi chieftain, the same chief who formalized the treaty for Fort Dearborn, now known as the city of Chicago. When translated into English, Topinabee means "Great Bear Heart."

Pellston was originally platted in 1882 by William H. Pells who sold some of the land to early settlers, although it was not incorporated as a village until 1907. It is situated in the middle of the Mackinaw State Forest, west of Douglas Lake on the west branch of the Maple River, approximately 19 miles north of Petoskey. Pellston is home to the Pellston Regional Airport. This town of 800 people is a fisherman's paradise. The Maple River is teeming with brook trout, brown trout, and rainbow trout, while Douglas Lake is stocked with northern pike, walleye, largemouth bass, smallmouth bass, crappies, bluegill, perch, sunfish, and rock bass. It is difficult to find a town as out-of-the-way as Pellston is, although the campers, fishermen, hunters, and snowmobilers who frequent the area don't seem to mind the peace and quiet.

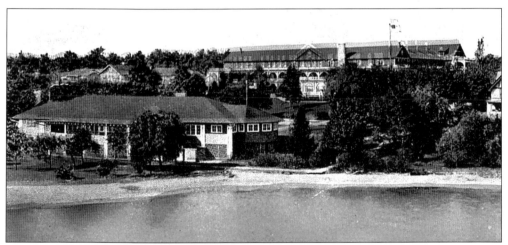

From the 1890s through its heyday in the 1920s, the Belvedere Hotel and Casino in Charlevoix was considered one of the most luxurious resorts in northern Michigan. Typical of the resorts found in Charlevoix during this period, the Belvedere was just as popular as its contemporaries, the Inn, the Beach, and the Hotel Elston. Today, the Park Place in Traverse City, the Perry Hotel in Petoskey, and the Grand Hotel on Mackinac Island are among the only remaining hotels of this period, although the spirit of resorts such as the Belvedere Hotel is still evident in northern Michigan.

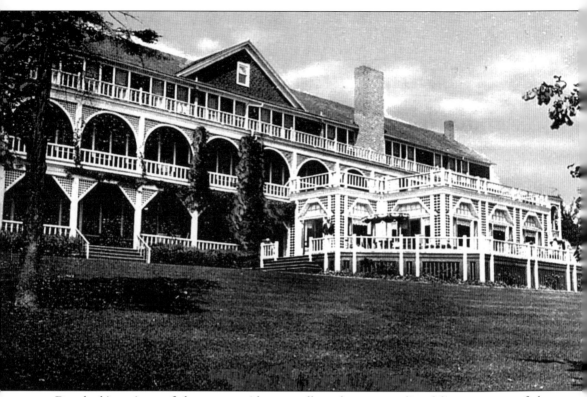

Breathtaking views of the countryside, as well as the surrounding lakes, are part of the experience for those who choose to play a round of golf at the Belvedere Golf Club in Charlevoix. Founded in 1925, the course opened for play in 1927, and has played host to the Michigan Amateur Championship a total of 38 times over the years. Known as a favorite among professional golfers, the Belvedere is located approximately 27 miles south of Petoskey.

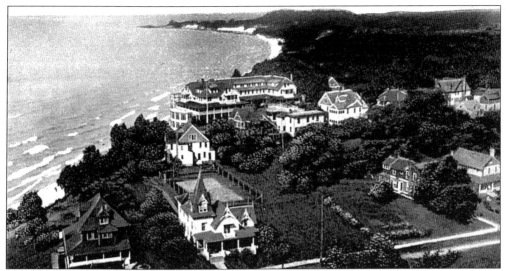

This aerial view of the lake and cottages in Charlevoix, south of Petoskey, shows just how popular tourism is in northern Michigan. Charlevoix has been a resort town since its inception, and while it is 27 miles from Petoskey, these two towns have a great deal of shared history. Not only are they both resort towns—Charlevoix swells from its native population of 8,500 to over 30,000 during the summer months—but both were stopping points for passenger ships and railroads. In fact, the rail lines to Charlevoix and Petoskey were built prior to those in Traverse City, and almost every passenger ship on its way north to Petoskey made a stop in Charlevoix along the way.

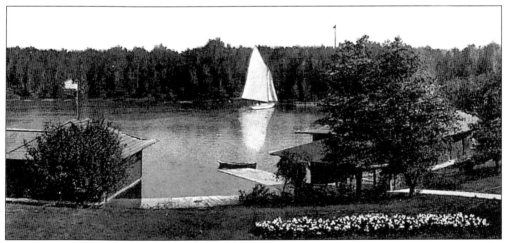

An afternoon spent sailing on Round Lake, down into Lake Charlevoix or even out onto the waters of Lake Michigan, is something that many residents and tourists look forward to. Although the Belvedere Hotel and a number of the older boathouses no longer grace the shoreline, having been replaced with marina slips and condominiums, the unique architectural heritage of the Charlevoix area can still be viewed across the cool, clear waters of Round Lake. Whether from the shore or aboard a boat, it is difficult to imagine that these lakes were once filled with logs on their way to the mill and the harbor was home to commercial fishing vessels. It is easy to see, from any vantage point, why this town has earned the name "Charlevoix the Beautiful."

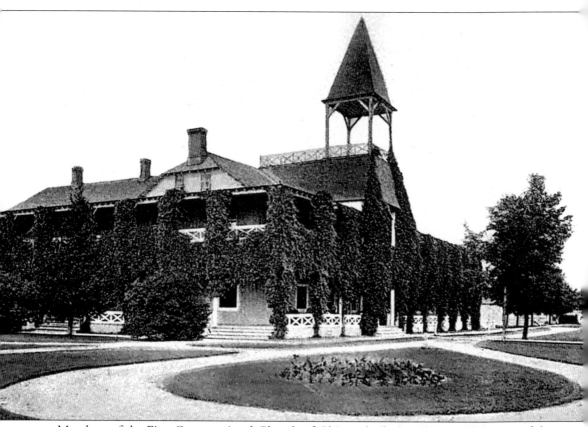

Members of the First Congregational Church of Chicago built the Chicago Club, one of the mainstays of the Chicago Summer Resort Association, in 1881. A private association, the Chicago Club is located on a private drive that overlooks Lake Charlevoix. Inspired by the Belvedere Club, another private association that was built on the Pine River Channel in 1880, the Chicago Club features some of the area's finest Victorian architecture. Upon completion, the Chicago Club sported a total of 27 bedrooms, a number of sitting rooms, dining rooms, and a fully-equipped kitchen. At the present time, the club and many of the summer homes are being used by a third generation of families. While these summer homes are still private, it is worth a drive on East Dixon Avenue merely to catch a glimpse of these architectural masterpieces.

Rustic bridges such as this one, located in the confines of the Charlevoix Summer Home Association, were a common site throughout northern Michigan in earlier days. In the summer of 1878, the first building was erected on what is now referred to as the Belvedere Club, and for a number of years afterward a great deal of construction took place. The result was a number of enormous Victorian-style summer homes with screened-in porches, balconies, vast well-manicured lawns, and at one time, the Belvedere Hotel. While the Belvedere Hotel, like the rustic bridges that crossed the Pine River channel, is no longer there, many of the summer homes still exist and are still owned by the original families.

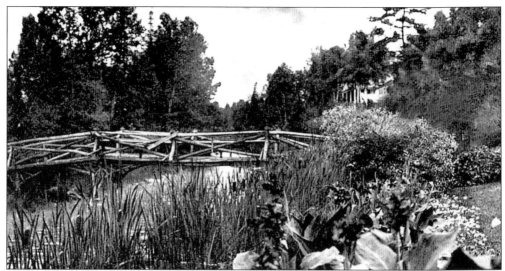

This image provides another example of the rustic bridges that wound their way through the Charlevoix Summer Home Association, as well as a number of other northern Michigan locations. It also shows the lengths to which residents went to maintain a natural setting. While these bridges and footpaths (some of which can still be found in the more rural areas of northern Michigan) were not built with regard to conserving natural resources, they did preserve the wilderness look of the area. In the summer months, vacationers would travel to resort towns such as Charlevoix, Harbor Springs, and Petoskey in search of a relaxing time in a wilderness setting, yet one with a modicum of creature comforts. These bridges, quaint and rustic as they may initially appear, played a vital role in the growth of tourism in northern Michigan.

While the swimming pool pavilions are no longer attractions at East Park, Depot Park, or the Charlevoix Municipal Launch, there remain a number of reasons why tourists flock to Charlevoix on a year-round basis. The parks, architecture, and small town atmosphere—not to mention its location on Round Lake and Lake Michigan—make Charlevoix one of northern Michigan's most popular vacation spots. The Municipal Launch and Public Beach are located on Round Lake, as is East Park in the heart of downtown Charlevoix. Depot Park is located on the shores of Lake Charlevoix, north of the bridge, near the site of the former railroad depot. All of Charlevoix's parks come alive with music, dancing, and arts and crafts during Venetian Festival, a mid-summer celebration held in July of each year.

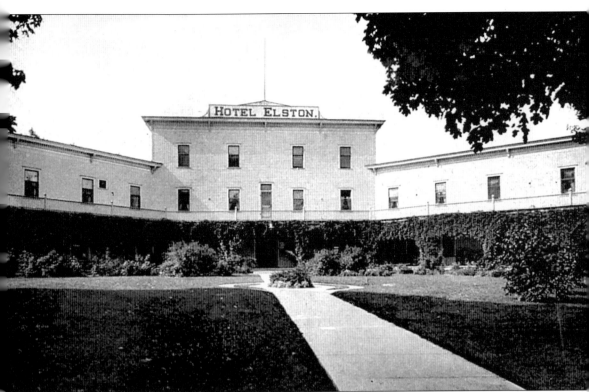

Construction on the Hotel Elston began in 1894 and was made possible by a private stock offering. The hotel was located at Lindsay Park, on the southeast shore of Round Lake, and was considered one of the best hotels in Charlevoix. It was built during the same era as the Chicago Summer Home Association, the Chicago Club, and the Belvedere Club. Like many of its competitors, the Hotel Elston fell victim to financial hardship, although the elegant design and graceful atmosphere of this and similar establishments remain difficult to match.

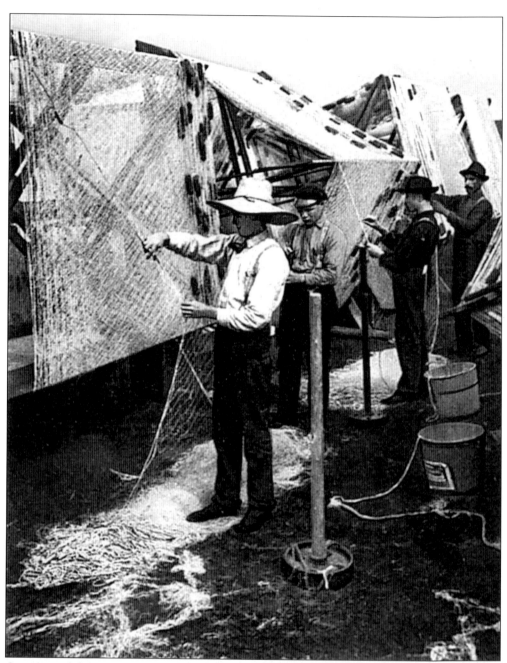

Commercial fishing on Lake Michigan was an integral part of the area's economy from the 1860s until the 1950s. Seine nets were never widely used in northern Michigan, although Pound nets, Gill nets, and Trawling sleds were quite popular. Pound nets are staked to the lake bottom and entire schools of fish are trapped in them, Gill nets are suspended by a system of weights and floats and catch their prey by the gills, while Trawling sleds are dragged behind a boat and force fish into a net. There are a number of reasons why commercial fishing has declined so drastically—primarily overfishing, pollution, and the introduction of non-native species to the Great Lakes.

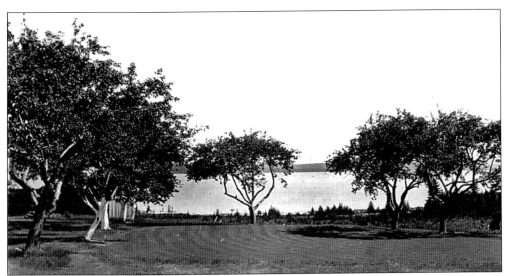

It seems as though at one time almost every lake, river, town, and village in northern Michigan was known by a different name than it is now. Lake Charlevoix is no exception, and there are probably few people, if any, who recall when it was known as Pine Lake. At its most southern points, the Jordan River and the Boyne River feed into Lake Charlevoix. The northernmost point of the lake adjoins Round Lake, which, through the Pine River Channel, flows into Lake Michigan. Up to 100 feet deep in some places, Lake Charlevoix is almost 13 miles long and almost one and a half miles wide in some areas. During the summer months, Lake Charlevoix bustles with activities that range from fishing and swimming to sailing and water skiing.

On the south side of Lake Charlevoix, just a few miles west of Boyne City, is where Dyer and Porter Creeks meet. The Advance Bridge gives travelers the means to cross this rather small waterway. The bridge, a wooden structure, crosses Dyer Creek at the point where it empties into Lake Charlevoix. For decades, this part of Lake Charlevoix, from the mouth of Dyer Creek to Whiting County Park, has been popular with fishermen who are trying to catch brown trout, smallmouth bass, lake trout, and walleye. The village of Advance was founded in 1866, but fell victim to declining prices in the lumber markets and closed its post office in 1907.

Appearing fairly somber for what seems to be a good day of bird hunting, these gentlemen proudly display their catch. While northern Michigan is not the bird hunting paradise that it once was, there are ample numbers of duck, pheasant, quail, and woodcock to satisfy even the most ardent of hunters. A number of designated areas in both Charlevoix and Emmet counties allow bird hunting. In Charlevoix County, the East Jordan Settling Ponds, Sportsman's Park, and Fisherman's Island State Park are popular sites, while Emmet County is home to areas such as Walloon Lake and Wilderness State Park. Sadly, as a result of unregulated bird hunting, the passenger pigeon was hunted in northern Michigan to the point of extinction.

The north branch of the Boyne River, just to the north of Boyne Falls, provides anglers with the opportunity to land that elusive brown trout, steelhead, or salmon. Less than a mile to the south of the river is Boyne Falls, one of the many towns that, in 1874, began as a stop for the Grand Rapids & Indiana Railroad. It was not until 1893 that residents incorporated the village of Boyne Falls, although the river and surrounding area had been given the name of Boyne a number of years earlier. It was in 1856 that a spiritualist by the name of Harriet Miller and her family found their way to northern Michigan, naming the river Boyne after a waterway in Ireland. Boyne Falls is located approximately 15 miles southeast of Petoskey in Charlevoix County.

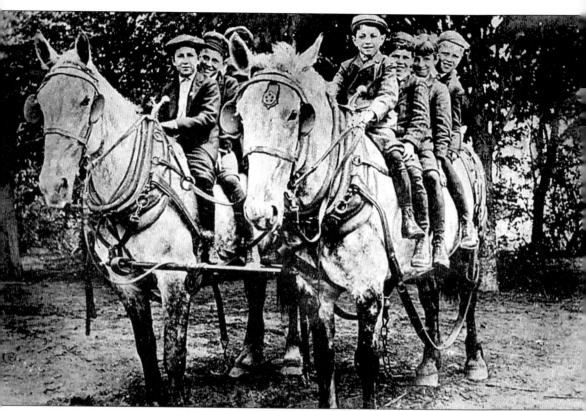

Located approximately 15 miles southeast of Petoskey is Boyne City, a town that in recent years has become known for its golf and ski resorts. At one time this area was better known as the primary residence of the Beulah Land Home for Boys. This foster home, despite becoming insolvent in 1913, provided Floyd Elliot Starr with the beginnings of what was to become Starr Commonwealth, a refuge for "homeless, dependent, neglected and wayward boys." While this foster home in Boyne City may have only lasted for about a decade or so, its lasting impact has been its role in the creation of Starr Commonwealth. Today, this nationally-recognized institution assists over 4,000 young people per year as a foster home and by offering intervention and prevention programs for young adults.

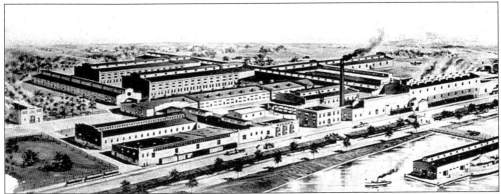

At one time, tanneries were almost as important to the development of northern Michigan as lumber companies, the budding tourist industry, and the railroads. While Boyne City is no longer known for its tanneries, there was a time when this town supplied much of the shoe sole leather in Michigan. The number of hemlock trees in the area prompted W.S. Shaw, a tanner from Canada, to build a business in Boyne City. Assisted by local entrepreneur, W.H. White, owner of the White Lumber Company, it wasn't long before Shaw's tannery had become one of the most successful enterprises in northern Michigan. In 1907 alone, the tannery produced more than 6,000,000 pounds of shoe leather. Shaw went on to found Boyne City Clay Products, a brick making company, whose bricks contributed to some of the older buildings in Boyne City.

Prior to the 1940s, Boyne City was known for its farmland, good fishing, and as the former site of Beulah Land—although Everett Kircher changed all of that. A Studebaker dealer from Detroit, Kircher purchased land from a retired state senator, and while many local residents considered it folly, he began building what was to become the largest privately-owned ski and golf resort in North America. Hills like Old Roundtop are now part of Boyne Mountain, a resort that offers 62 downhill ski runs, cross country trails, and world-class golf courses. In fact, Charlevoix and Emmet counties are now touted as being Boyne Country.

Over the years, a number of changes have taken place in and around Boyne Country, an all-encompassing term that includes Boyne City, Charlevoix, Petoskey, Bay View, and Harbor Springs. Outside of the boom and bust of the lumber operations in the early 20th century, the ever-growing resort industry has had the greatest impact on northern Michigan. A significant part of that growth has taken place since the 1940s, when downhill skiing was popularized in northern Michigan. Areas such as Peaceful Valley, the meadow at the base of Old Roundtop, have undergone significant changes. Today, the valley is still there, as is Old Roundtop, and the view from atop this hill remains unparalleled, a sweeping vista enjoyed by those who frequent the ski hills at Boyne Mountain.

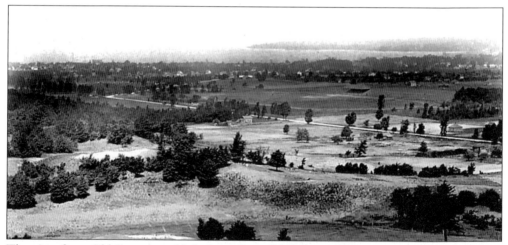

The view from Old Roundtop, high above Peaceful Valley and Boyne City, is nothing short of magnificent. Outside of the fact that the hill is now part of Boyne Mountain, a ski resort located just outside of Boyne City, little else has changed in this part of Charlevoix County. While there has been a flurry of residential construction in recent years, residents are aware of the fact that one of the primary reasons people relocate to northern Michigan is to get away from more developed areas and simplify their lives. Here, just outside of Boyne City, it is still possible to go for a bike ride, take a walk, or even go for a country drive in a natural setting.

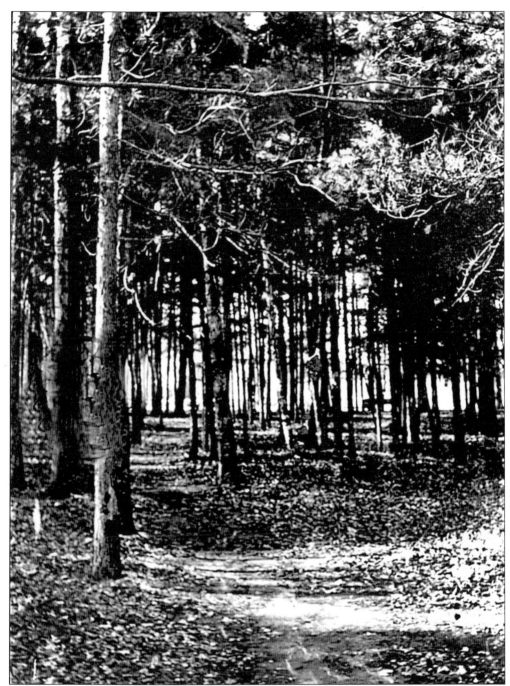

During the summer months, Whiting County Park and Young State Park, both located on Lake Charlevoix, are favorites among campers, anglers, boaters, swimmers, and children who merely want to play in the sand. Both hikers and skiers can enjoy the beauty of Avalanche Preserve, 300 acres of wilderness terrain featuring the Stairway to Heaven and Avalanche Overlook. In February of each year, Boyne City hosts Winter Fest, a celebration of winter fun that includes everything from frozen turkey bowling and a frozen fish toss to a cardboard sled race.

A scenic drive in and around the Boyne City area is always a fun way to spend the afternoon, and autumn is a spectacular time of year to plan a visit. During Indian Summer, the leaves on most of the trees turn from lush green into a virtual rainbow of colors. The beeches, birches, and maples of Boyne City and most of northern Michigan come alive with a vibrant display of varying hues. This is the grand finale to nature's fireworks, an annual show that leaves residents and tourist alike in awe. The residents of Boyne City are more than happy to greet visitors any time of year.

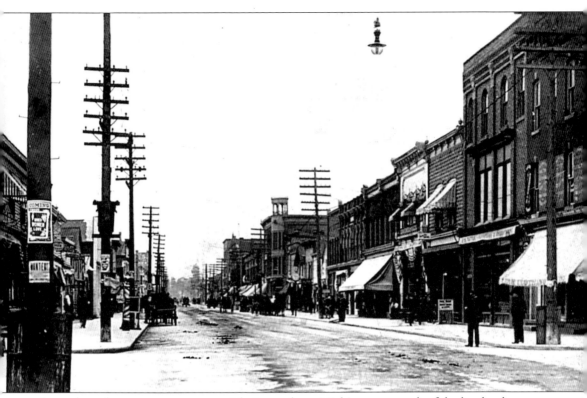

A number of towns sprang up overnight in northern Michigan as a result of the lumber boom, and they were particularly attractive to those who were interested in homesteading. There was not only employment in places like Cheboygan, Petoskey, and Traverse City, but the federal government had made thousands of acres of land available through the Homestead Act of 1875. This image of Main Street in downtown Cheboygan is typical of an early 20th century lumber town—a town in transition. While the lumber industry was reaching its last days, tourism had already become an economic force, one that would forever change the face of northern Michigan.

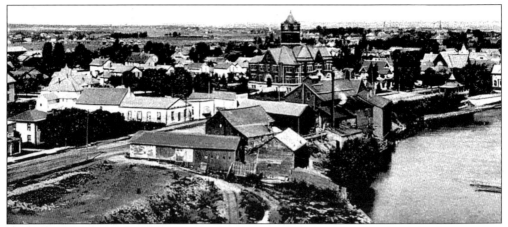

Cheboygan is a mere 41 miles east of Petoskey, slightly more on the Inland Waterway. Inhabited for centuries by Ottawa and Chippewa Indians, fur traders arrived in the Cheboygan area in the 1600s, although there were no permanent settlers until the 1840s. As with most northern Michigan towns, Cheboygan enjoyed a great deal of prosperity during the lumber boom—especially since it was on the Inland Waterway, as well as on the shores of Lake Huron. Tourism has become a major part of Cheboygan's economy, and today it is known for its commercial fishing, farming, and paper manufacturing industries. Since the days when Native Americans portaged their canoes, those of the lumber industry, and modern-day tourism, the Inland Waterway has created a natural relationship between Cheboygan and Petoskey.

Raising sheep in northern Michigan presents some unique problems, and while a number of people have attempted over the years to introduce ewes and rams to the area, their efforts have been met with mixed results. The winters in Cheboygan and Petoskey tend to be hard on livestock, and while most of the herds are located in the middle of the state, there are a few in northern Michigan. Stories of shepherds driving sheep from Ohio to Michigan at the dawn of the 20th century are common, yet it has historically been fruit farming, not ranching that has survived the climactic changes. Rural areas in Antrim and Charlevoix counties are home to the North Country Cheviot, Shetland, and Suffolk breeds, although according to a recent livestock census, sheep are no longer being raised in northern Michigan.

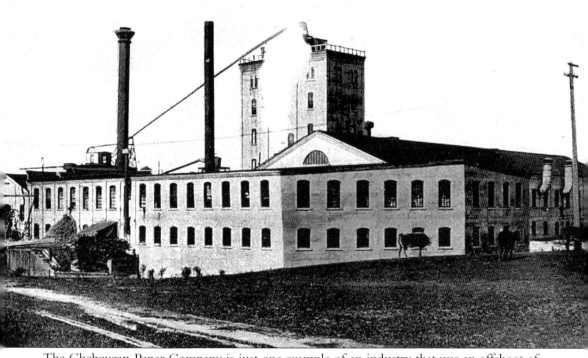

The Cheboygan Paper Company is just one example of an industry that was an offshoot of the lumber boom in the early part of the 20th century. Mills such as this one, which provided a major source of employment, had an industrial base. Many mills opened in the 1920s and operated up until the late 1960s or 1970s. While companies such as the Cheboygan Paper Company gave a boost to the area economy, the cost of doing business in northern Michigan forced a number of facilities to either relocate or close down. These businesses were facing not only increasing transportation costs, but also stricter environmental standards. These days, Lake Huron and the Cheboygan River are primarily used for recreational activities.

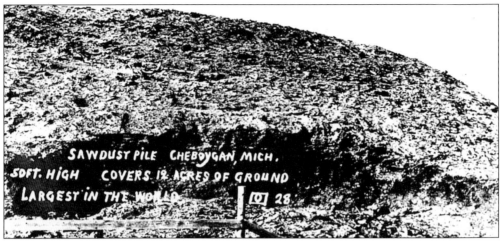

Major City Park, a five-acre site on the banks of the Cheboygan River, is now a place where families can come to picnic, little league teams play baseball games, and children play on the swing set—although for over a century it was one of Cheboygan's largest tourist attractions. At one time, it was not a park, but rather it was home to what has been called the 'world's largest sawdust pile': 80,000 tons of Cheboygan's industrial past. In the 1980s, much of the downtown area was renovated and the sawdust was used to cover up an old landfill. The park, off of Cleveland Avenue on the south bank of the Cheboygan River, is now a sign of the city's future, rather than its lumbering past.

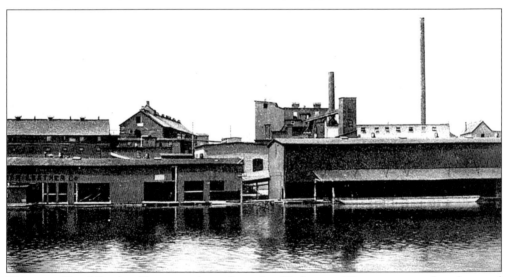

Phister & Vogel Leather Tannery, situated on the Cheboygan River, once employed several thousand Cheboygan-area residents. This particular location made it easy to secure the lumber used in the tanning process, and also provided a means by which the finished product could be transported. Railroad lines, such as those owned by the Chicago & Mackinac Railroad, were instrumental in transporting goods to market, as well as offering passenger service on a limited basis. In addition, a location on the Cheboygan River gave Phister & Vogel direct access to Lake Huron and the freighters that were so crucial in ensuring access to markets on the eastern seaboard. While Phister & Vogel had a positive economic impact on the Cheboygan area, its days were numbered as transportation costs rose and environmental laws became tougher.

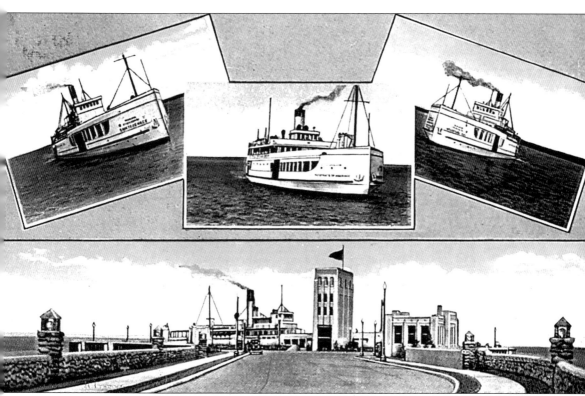

The connection between the towns of Petoskey, Cheboygan, and Mackinaw City is more than geographical. Each of these towns played a major role in the development of the other, and while Cheboygan and Petoskey are both larger than Mackinaw City, transportation has been integral to their growth. Many ferries and freighters sailing on Lake Huron stopped at Cheboygan, as well as the Michigan State Dock at Mackinaw City, on their way to Petoskey and other harbors on Lake Michigan. Conversely, many ships sailing out of Petoskey did the same as they rounded the Straits of Mackinac and crossed over into Lake Huron. At one time, all of these towns were also part of Michigan's lumber boom.

Powers Beach, a serene, wooded stretch of sand, is located in a cove on the north side of Mullett Lake near Cheboygan. This beach, only a short distance away from the Cheboygan River, is on the eastern end of the Inland Waterway. The lake is especially popular with anglers, although the water tends to be shallow for some distance out from the shoreline and in order to catch any fish of size, a boat is likely needed. During the winter months, the lake is dotted with ice fishing shanties, while nearby the snowmobile and cross-country ski trails are busy with activity. Mullett Lake is one of Michigan's year-round recreational inland lakes.

Considered one of Michigan's blue ribbon trout streams, the Upper Black River extends northward from Black Lake and eventually flows into the Cheboygan River, just to the east of Mullett Lake. While the Upper Black River is well-known for its trout fishing, the point at which it empties into the Cheboygan River was once just as popular with logging companies. Sawmills and tanneries lined the banks of both the Upper Black River and the Cheboygan River, all the way into town. While the river is not very long, approximately six miles in length from Black Lake to the Cheboygan River, it provides a glimpse of what Michigan looked like in the past. The vacationers who canoe, fish, and kayak the Upper Black River are taken aback by its natural beauty.

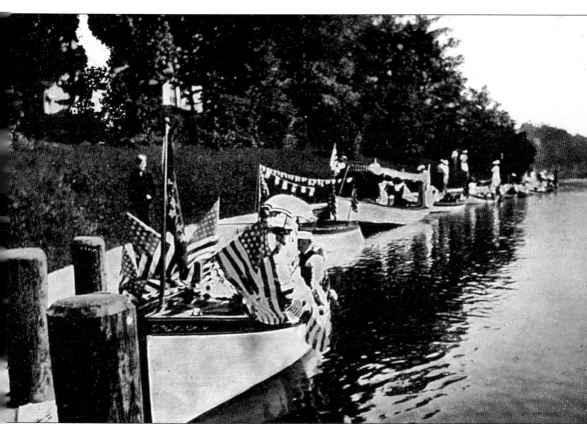

Decked out for what appears to be a Fourth of July Parade on the Cheboygan River, these yachts are in full regalia. The unique geological formations that created the Great Lakes basin during the last Ice Age, approximately 25,000 years ago, also created the Inland Waterway. As a result, vessels are able to travel from Port Huron down the Cheboygan River to Mullett Lake, the Indian River, and Burt Lake to the Crooked River and Crooked Lake, leaving only a short portage to Little Traverse Bay and Lake Michigan. Both scenic and beautiful, the Cheboygan River, and in fact the entire Inland Waterway, is busy with boaters, fishermen, and swimmers from early June until late September. During the high season and on special holidays, there are bound to be flotillas of every shape, size, and color on the Cheboygan River.

One of the oldest parks, if not the first park, in Cheboygan, Washington Park is located on Main Street next to the Cheboygan Area Chamber of Commerce. Near the banks of the busy Cheboygan River, Washington Park is filled with mature trees, although most of the older ones which were bent and twisted for use as trail markers by the Ottawa and Chippewa Indians no longer exist. This neighborhood park is in the heart of downtown Cheboygan, only a short walk from the city's quaint downtown shopping district and the shore of Lake Huron. Once a passageway used primarily for logging, today the Cheboygan River is well-known as a recreational area for fishermen and boaters.

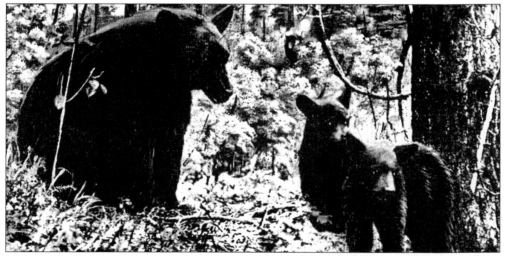

As more people tend to move to northern Michigan, there is less and less habitat for Black Bears, although Cheboygan and Emmet counties are still considered to have sizeable populations. According to the Michigan Department of Natural Resources, over 90 percent of all the Black Bears living in Michigan reside in the Upper Peninsula. When settlers first came to northern Michigan, there may have been a few more bear attacks, merely as a result of them being driven from their homes. It is quite unlikely that a hiker or camper would come upon a bear these days. Because they have a natural fear of humans, they would most probably flee into the woods. While they appear cute and cuddly, the best advice is never to approach a bear under any circumstances.

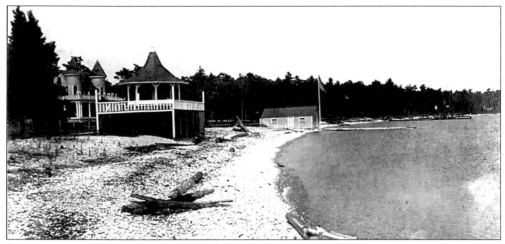

Pointe aux Pins is located on Bois Blanc Island, from which it is possible to view Cheboygan. There only two ways to reach the island, by airplane or on board a ferry out of Cheboygan. This island lies a few miles southeast of Mackinac Island and Mackinaw City, and only a couple of miles north of Cheboygan. It is home to approximately 45 permanent residents. The woods on the island were previously home to a lumber company, although the island's location, as well as its shallow harbor, made it treacherous for ferries and steamships. Today, Pointe Aux Pins remains as an island resort town, although the rest of Bois Blanc, referred to as Bob-Lo, is owned by the state of Michigan.

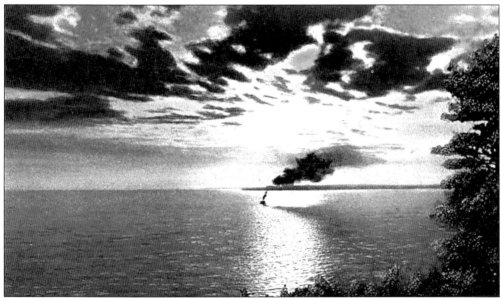

Sailing around the Straits of Mackinac, either under the moonlight or on a sunny day, is an adventure that every boater cherishes. Whether heading north and east on Lake Michigan, above Petoskey and Harbor Springs, or north and west on Lake Huron past Cheboygan and Bois Blanc Island, the lakes' beauty is beyond description. At the same time, it is easy to see why the Ottawa and Chippewa Indians preferred to canoe the Inland Waterway, instead of taking their chances on Lake Huron and Lake Michigan. After all, a canoe is no match for these waters, especially considering the fact that freighters and steamers have gone down in the Great Lakes.

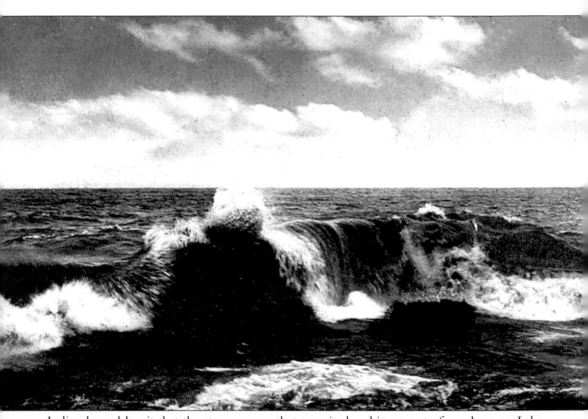

Indian legend has it that the storms, ones that seemingly whip up out of nowhere on Lake Michigan, are the creation of the Manitous, or important spirits, who are upset with people for one reason or another. There are days when waves crash onto the beach and Lake Michigan seems to be on a rampage, although these are the exception, not the rule.

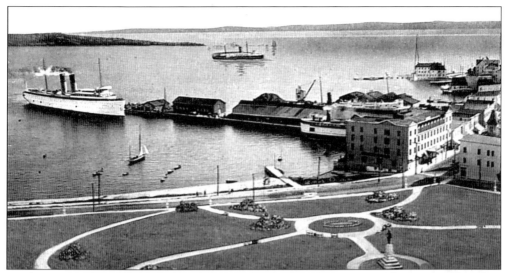

Mackinaw City boasts that it is "Michigan's Favorite Vacation Getaway" featuring no less than three National Historic Sites: Historic Mill Creek, Colonial Michilimackinac, as well as the Old Mackinac Point Lighthouse. While the village was not established until the 1860s, French fur traders had been trapping in the area since the 1600s. The French built Fort Michilimackinac in 1714, which, after changing hands between the French and the British several times, became part of the United States as a result of the Treaty of Paris. This village of slightly fewer than 1,000 residents, located at the northern tip of Michigan's lower peninsula, was once one of the busiest ports on the Great Lakes. Once the lumber boom ended, the town developed its tourist economy. Mackinaw City is approximately 36 miles north of Petoskey.

A fond memory for many newlyweds and vacationing families, rustic cabins such as The Breakers were a common site in Mackinaw City until just recently. The popularity of Mackinaw City in recent years has lead to the construction of a number of large hotels, replacing the cozy cabins of yesteryear. In fact, this small town of fewer than 1,000 residents now hosts over 6,000,000 vacationing tourists annually. An abundance of historical sites in Mackinaw City, as well as the Mackinac Bridge, nearby Mackinac Island, and the prospect of a trek across the Straits of Mackinac into the Upper Peninsula of Michigan have attracted tourists from around the world. For most of the 20th century, tourism has played a vital role in Mackinaw City's economic development.

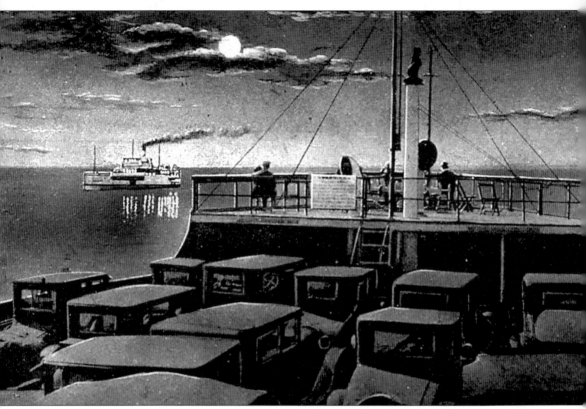

Ferries crossing the Straits of Mackinaw transported automobiles and their drivers from Mackinaw City to St. Ignace on a daily basis until the Mackinac Bridge opened on November 1, 1957. Today, the only ferries that operate on the Straits of Mackinac are those privately-owned shuttles that transport tourists to Mackinac Island. The Mackinac Bridge, currently the third longest suspension bridge in the world, spans a total distance of 26,732 feet, or five miles. Recreational watercraft have taken the place of the ferries and freighters that were once a common site on the Straits of Mackinac. By June 25, 1998, over 100,000,000 vehicles had crossed over the Mackinac Bridge.

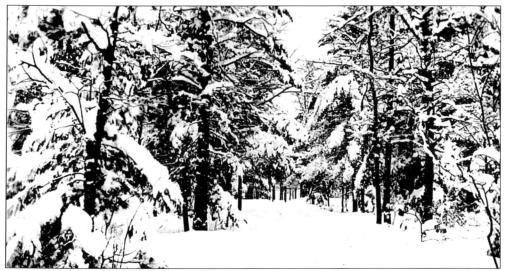

Bellaire, located to the east of Torch Lake in Antrim County, is midway between Petoskey (to the north) and Traverse City (to the south). The average annual snowfall in Bellaire is approximately 35 percent less than that of Petoskey. On an annual basis Petoskey receives an average of 117 inches of snow, while Bellaire's winter weather is much milder, amounting to only 76 inches. While the winds coming in off of Little Traverse Bay create snowdrifts, Petoskey is less rural than Bellaire and, as a result, the accumulation does not seem as great. This entire corner of northwest Lower Michigan is, in fact, a snow belt and much of it is the result of lake effect snow.

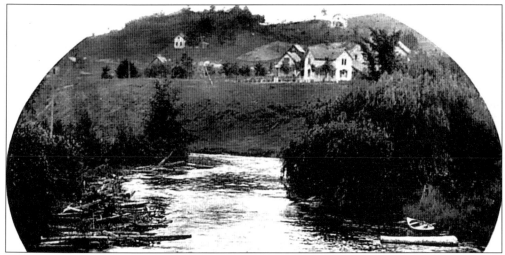

Antrim County is home to the Intermediate River, a waterway that flows from Intermediate Lake south through the town of Bellaire and empties out into Lake Bellaire. Intermediate River is a part of the Chain O' Lakes, an inland route that includes 12 lakes, as well as several connecting rivers. The Lower Chain O' Lakes includes Intermediate Lake, Lake Bellaire, Clam Lake, Torch Lake, Lake Skegemog, and Elk Lake, while the Upper Chain O' Lakes features Six Mile Lake, Hanley Lake, Benway Lake, Wilson Lake, and St. Claire Lake, as well as the Grass River, Intermediate River, Clam River, and the Torch River. Families take to the Chain O' Lakes, as well as the Inland Waterway, in droves during the summer months.

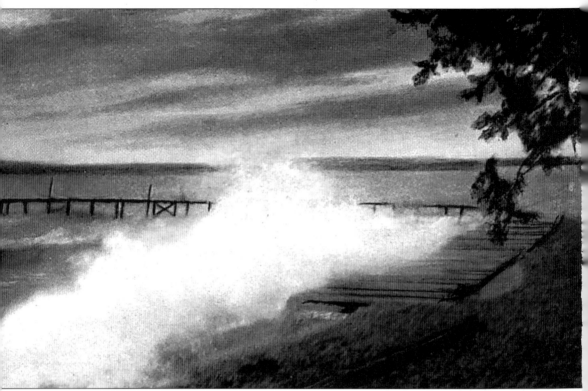

There are times when the waters of Little Traverse Bay are calm and almost glass-like, although every now and then, a storm arises and sends whitecaps crashing up onto the break wall. For the most part, Little Traverse Bay provides a modicum of shelter from the storms that roll in off of Lake Michigan, a safe haven for ships. This inlet is a favorite among divers, sailors, and swimmers and is as well-known for its beauty as it is it ferocity. It was here that ships from Detroit and Cleveland would make their first stops on Lake Michigan after rounding the northern tip of the Lower Peninsula.